THE NAKED CARTOONIST

THE NAKED
CARTOONIST

ROBERT MANKOFF

BLACK DOG
& LEVENTHAL
PUBLISHERS
NEW YORK

FOR MOLLIE AND LOU

ISBN 1-57912-236-1

Library of Congress Cataloging-in-Publication Data is on file and avail-
able from Black Dog & Leventhal Publishers, Inc.

Book design: Martin Lubin Graphic Design

Printed in Spain

PUBLISHED BY

Black Dog & Leventhal Publishers, Inc.
151 West 19th Street
New York, New York 10011

DISTRIBUTED BY

Workman Publishing Company
708 Broadway
New York, New York 10003

g f e d c b a

Contents

INTRODUCTION

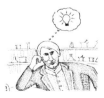

ACKNOWLEDGMENTS

Where to begin? At the end, of course. So let me thank *you* for buying this book. Without you, and people like you, me, and people like me, would end up out on the street, selling cartoons for the price of a cheap bottle of booze instead of riding around in stretch limos with blacked-out windows and a wet bar, looking down on people like you. Not that I think I'm better than you. Far from it. I'm sure that in almost every way conceivable you're the superior individual, but, dammit, stop trying to look in the limo—those windows are blacked out for a reason!

Next I'd like to thank the forces of globalization which enabled this gorgeously produced book to be printed so cheaply in the tiny village of Gzbikstivitz, on the shore of lovely, palindromic Lake Ztivitskibzg.

Closer to home, endless gratitude is owed, first and foremost, to the cartoonists past and present of *The New Yorker* magazine, and to the magazine's surprisingly tall editor, David Remnick, who, since he has been at the helm, has let a loose cannon like me career about the deck in the hope that every once in a while I'll get a shot off in the right direction.

Second and foremost in the gratitude queue are J. P. Leventhal, who gave the go-ahead; and, of course, my eminently sane editor, Laura Ross, who kept pushing this crazy project forward against all my back-sliding, excuses, and evasions. Laura would not be denied, evaded, or placated, except with pages ("Pages, Bob, we need pages. And if it's not too much trouble, please put something on them this time"). And once I did, she and a host of other meddlers, including but not limited to Ben Greenman and Jane Cavolina, not to mention designer Martin Lubin, which I just did, helped turn an inchoate mess of images and ideas into the choate mess you have before you.

Even closer to home, in my own home in fact, I must, and I do mean must, acknowledge the contributions of my third and best wife, Cory, who simply insisted that I write a book that would make us fabulously wealthy. Well, Cory, I've done my part. Now it's up to them and people like them.

1 Me, Myself, and *The New Yorker*

Hi, I'm Bob Mankoff, the cartoon editor of *The New Yorker* magazine. This is my world, and welcome to it. Come on in, but watch your step. You could slip.

Actually, I can see you're a bit shy, so why don't we get acquainted first.

First, let me tell you a little bit about yourself. Presumptuous of me, I know, but computerized projections of who would buy this book are really quite accurate. However, you are a little taller than I expected.

The data suggest you've got a great sense of humor. We'll test you later, just to make sure (page 123, The Cartoon I.Q. Test), and if you pass you may qualify for one of these. It's like a poetic license, only funnier.

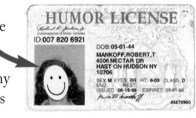

You'll need it to practice cartooning in New York and many other states. It comes up for review every two years, and its requirements are subject to change at the discretion of the management (of which there is none).

Now, what else do I know about you? Only this, for sure: You were born with a gift for laughter and a sense that the world is mad. Only people like that buy books like this— or write them.

In my case, those characteristics led to my becoming cartoon editor of *The New Yorker* in 1997. Best job in the world, greatest professional day of my life—except for a day, twenty years earlier, when I sold my first cartoon to *The New Yorker*.

June 20, 1977

I've sold more than six hundred since, but for me none compares with that first one. That took years and years to sell.

First, there were all of those misspent years failing at other things. Failing at being a welfare worker (actually becoming eligible for benefits myself), at teaching speed reading (my "What, Me Hurry?" T-shirt was thought to send a mixed message), and, finally, failing as a Ph.D. candidate in experimental psychology.

Why was I even in a graduate program in experimental psychology to begin with?

To make a long story short, I don't remember, but I'm pretty sure it had something to do with the war, and the time me and my buddies weren't in Nam. Whatever. The sweep of history and the fear of death landed me at Queens College in 1974, on the cusp of getting my doctorate in experimental psychology. My mother was overjoyed.

I didn't share her enthusiasm. I was so close to being a "doctor" that I could taste it, but it didn't taste good. My gift for laughter and my sense that the world was mad were rapidly dissipating, as I learned more and more about what I was less and less interested in. And my experimental animal, a rat, had no sense of humor at all.

"My son, the doctorate!"

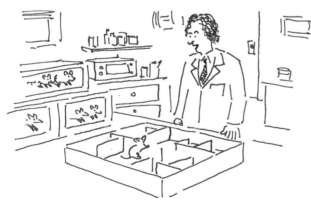

"But, seriously, you can't miss it. Just take a right and then two lefts."

So I quit, figuring that if I was going to fail, I might as well fail at something I liked.

But I seemed to have lost my knack for failure. Almost immediately, I began selling cartoons to a variety of magazines, including *The National Lampoon* and *The Saturday Review*.

"Please tell the king, I've remembered the punch line."

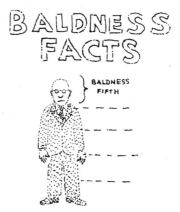
BALDNESS FIFTH

Baldness affects one-fifth of all men, that fifth usually being the part that includes the head.

Everyone is, to some extent, bald. Even in an individual with a full head of hair, the spaces between the hairs are hairless (see arrows).

Heredity is important. For example, if both your parents are bald, you will be too, so as not to be conspicuous.

"Elementary, my dear Watson: the cartoonist did it."

I was doing it! I was having my cartoons appear in magazines, but as far as I was concerned I was still in purgatory, because I couldn't sell a cartoon to *The New Yorker*.

"We are not amused—yet."

I had been submitting for two straight
years, every week, ten cartoons a week.
All I had to show for it were enough
rejection slips to wallpaper my bathroom.

We regret that we are unable
to use the enclosed material.
Thank you for giving us the
opportunity to consider it.

They were turning down cartoons like
these. Hundreds of them.

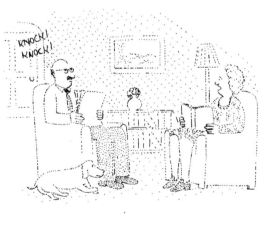

"Quick! Hide! That may be my husband."

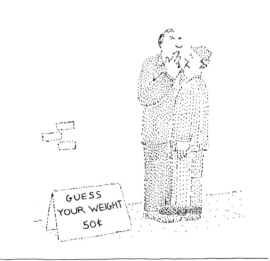

I kept on submitting them anyway, know-
ing that I had only one bathroom.

My obsession wasn't unusual. When I was breaking in, every professional magazine cartoonist submitted cartoons to *The New Yorker*. Paraprofessionals as well. Plus the great, the near-great, and the half rate from other fields. They still do. After I became cartoon editor, I received this note from the playwright David Mamet:

To which I replied:

Dear Mr. Mamet,
Thank you very much
for your submission.

 Bob Mankoff

P.S. I've taken the
liberty of sending you
a play.

Why would one of America's finest playwrights subject himself to this? Why does every professional cartoonist worth his salt or salt substitute (the job breeds hypertension) subject himself to this? Why did I? Simple: *The New Yorker* is to cartooning what God is to religion. It basically created the magazine cartoon as we know it.

Before *The New Yorker*, cartoons looked like this:

"Yes! Yes! This is Mr. Jones. I am going to luncheon and I will not talk to anyone until I have finished."
"Oh! Pardon me for interrupting you! I merely wished to inform you that your house is afire!"

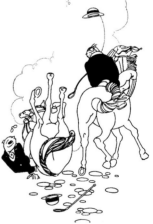

Voice from the Wreck—WHY IN THE NAME OF HEAVENS DON'T YOU WATCH WHAT YOU'RE DOING?
Unskilled Equestrian (apologetically)—QUITE RIGHT, OLD CHAP, I ENTIRELY AGREE WITH YOU! BUT DO SPEAK TO MY HORSE ABOUT IT, WON'T YOU? I HAVEN'T ANY INFLUENCE OVER HIM AT ALL.

In *The New Yorker*, they began to look like this:

"Touché!"

"George! George! Drop the keys!"

By the 1930s, *The New Yorker* had transformed the magazine cartoon from an elaborate, illustrated anecdote into a concise comic idea whose hallmark was a compelling image with a single-line caption. Later, that template would be extended and supplemented to include visions as diverse as those of Saul Steinberg and Roz Chast, but it still remains the platonic

"Makes you kind of proud to be an American, doesn't it?"

ideal of the cartoon, the basic mold out of which 90 percent of all magazine cartoons are stamped. Each one is like a classic comedy film compressed into a single frame. A world of social satire and insight fit into a four-inch rectangle.

Over the years, I've stamped out quite a few myself. Here's a quick retrospective, a snapshot of my career since I sold that first *New Yorker* cartoon in 1977.

The Seventies

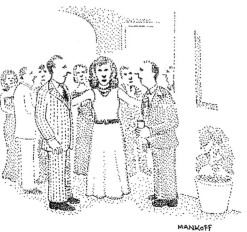

"I'd like you two to meet. Individually, neither one of you is very interesting, but together I'm hoping for a synergistic effect."

The Eighties

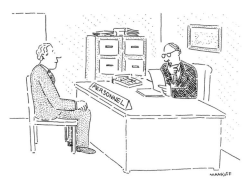

"Hmm, summa cum laude—very impressive. But what, exactly, is a Bachelor of Arts & Leisure?"

"Now, this over here, this is why you're going to have to go to jail."

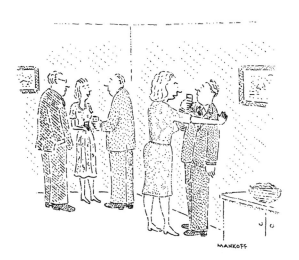

"You're not one of those guys who are afraid of intimacy, are you?"

"On Wall Street today, news of lower interest rates sent the stock market up, but then the expectation that these rates would be inflationary sent the market down, until the realization that lower rates might stimulate the sluggish economy pushed the market up, before it ultimately went down on fears that an overheated economy would lead to a reimposition of higher interest rates."

The Nineties

"Why, you're right. Tonight isn't reading night, tonight is sex night."

"As a matter of fact, you did catch us at a bad time."

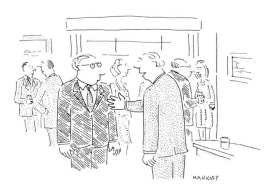

"Hi. I'm, I'm, I'm . . . You'll have to forgive me, I'm terrible with names."

"No, Thursday's out. How about never—is never good for you?"

"One question: If this is the Information Age, how come nobody knows anything?"

The Ohs

(or whatever you call them!)

"We think it has something to do with your genome."

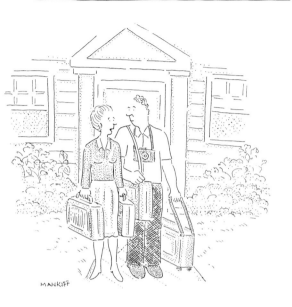

"Wait a minute—I know there's something we've forgotten to worry about."

"Great PowerPoint, Kevin, but the answer is still no.

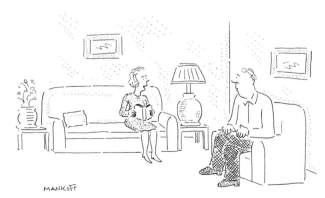

"I'm sorry, dear. I wasn't listening. Could you repeat what you've said since we've been married?"

I like to think of this little oeuvre of mine as nicely nestled amid the more than 60,000 cartoons that *The New Yorker* has published. These 60,000 cartoons represent a comic chronicle of the world from the 1920s until today. They also represent the extremely, I might even say hypercreative, individuals who produced them. Like me, they had to produce thousands and thousands of ideas in order to have hundreds published in *The New Yorker*.

Every week, my in-box looks like this. How they do it, how I do it, is part of what this book is about. If you want to be a cartoonist, I hope it inspires and helps you to create lots of cartoons.

But even if you have no interest in being a cartoonist, I think the book will show you what the creative life is like, and how, by understanding and using the principals of creativity, you'll be able to work more productively, no matter what field you're interested in.

Everything I need to know about creativity I learned from cartoons and cartooning. Pay attention, and you might pick up a thing or two yourself.

2 What Is a Cartoon?

"Me, sir. I'm a cartoon."

A

B

Well, bless your little plucky heart, but no, you're just a cartoon character. Not a whole cartoon. Neither is A, which is an illustration in cartoon style, or B, which is just the same thing but marginally more clever. But, with all due immodesty, I think C and D make the grade.

C

D

"I'm telling you. You're just thinking about it too much."

"But, sir, aren't C and D bad grades?"

(It's humiliating to be heckled by your own cartoon character, in your own book, but I can't do anything about it. These guys have a union.)

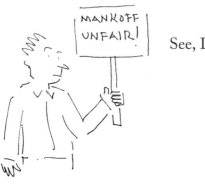

See, I told you.

But, my own character's protestation notwith-standing, the cartoons I'm talking about are more than simplified funny drawings of people, animals, or situations. Drawings need ideas to turn them into cartoons.

Take this drawing of mine, for example.

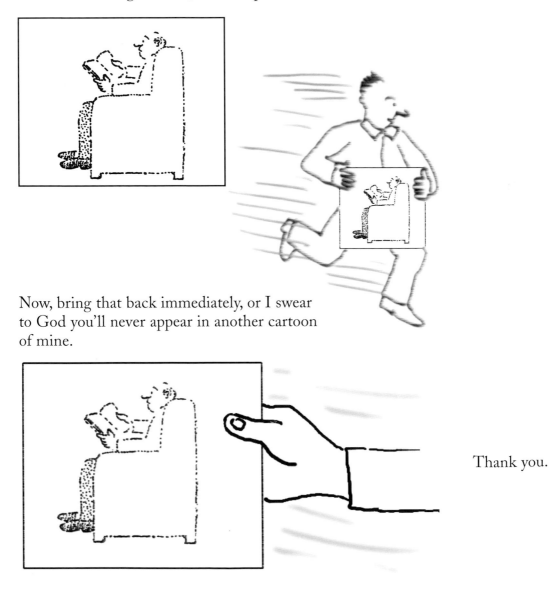

Now, bring that back immediately, or I swear to God you'll never appear in another cartoon of mine.

Thank you.

Anyway, all that's really necessary to transform this drawing into a cartoon is to turn it on its side. Then add an idea. Like this:

Here are a few more simple examples. All these drawings need in order to become cartoons is just a little more inking—and a lot more thinking.

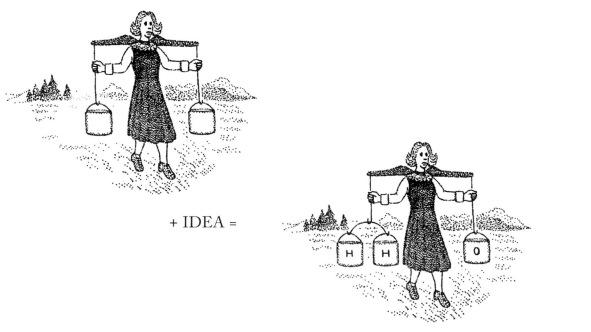

+ IDEA =

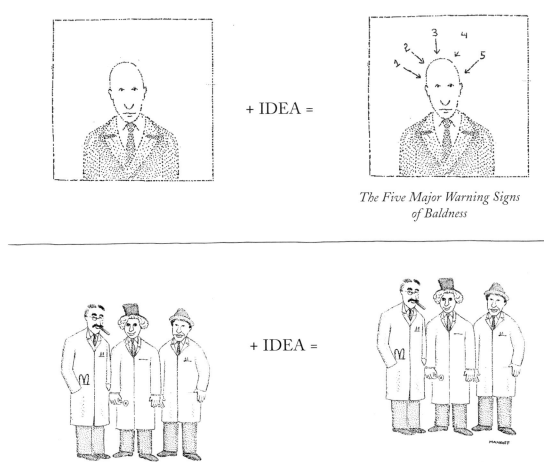

+ IDEA =

*The Five Major Warning Signs
of Baldness*

+ IDEA =

Three Out of Four Doctors

This example from Jack Ziegler cinches the case.

Here's one from Sam Gross.

Get the idea? It's not the *ink*, it's the *think* that makes a great cartoon.

Often, there's little visual difference between a drawing that works as a cartoon and one that doesn't. The difference is conceptual—and that's a huge difference.

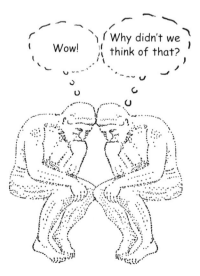

Probably because you guys are too logical. Now, it might seem that logic produces cartoons like the one below, but what's at work is really another mental function altogether. Creativity.

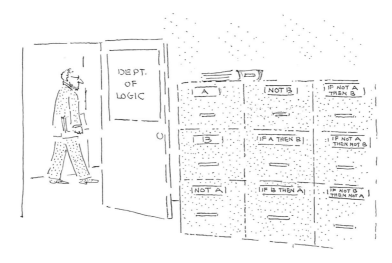

And, while logic proceeds, step by small, explicable step, creativity vaults to its end in one great leap.

Logicians can teach you logic, but it is cartoonists who can teach you creativity. Cartoonists? Not artists, writers, scientists, or accountants? Well, creative accounting is a felony and, anyway, I just threw in accounting to be funny. But what about the other three?

I don't wish to disparage the creative capabilities of these worthy professionals at length, so I'll do it quickly with cartoons instead.

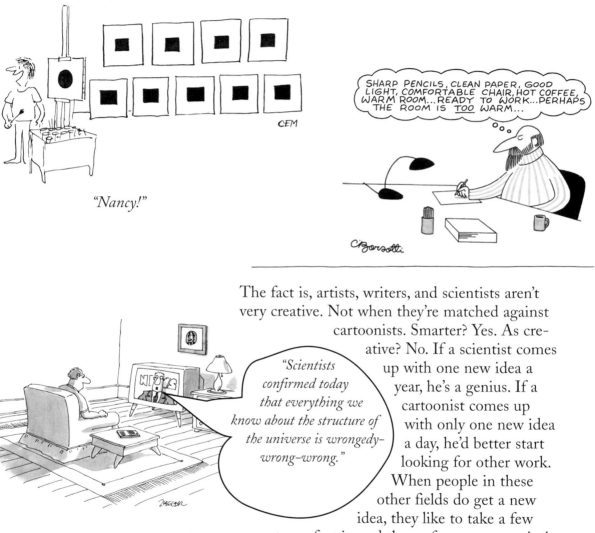

"Nancy!"

SHARP PENCILS, CLEAN PAPER, GOOD LIGHT, COMFORTABLE CHAIR, HOT COFFEE, WARM ROOM...READY TO WORK...PERHAPS THE ROOM IS *TOO* WARM...

"Scientists confirmed today that everything we know about the structure of the universe is wrongedy-wrong-wrong."

The fact is, artists, writers, and scientists aren't very creative. Not when they're matched against cartoonists. Smarter? Yes. As creative? No. If a scientist comes up with one new idea a year, he's a genius. If a cartoonist comes up with only one new idea a day, he'd better start looking for other work. When people in these other fields do get a new idea, they like to take a few years to perfect it, and then a few more to ruin it.

Magazine cartoonists don't have that luxury. The core prerequisite for the occupation is creativity. They get paid for their ideas, and they have to come up with a whole lot of them every week, because nine out of ten will be rejected by fussy editors like me.

The necessity for producing new ideas at warp speed doesn't mean cartoonists don't occasionally get stuck for ideas. We do, but that's just the stimulus for getting ideas—about getting ideas or about not getting ideas.

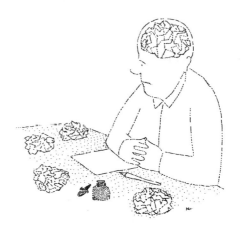

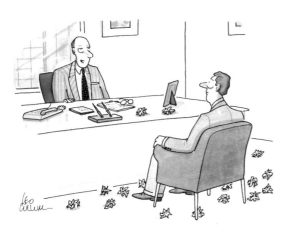

"Well, Stoddard, I think I've bounced enough ideas off you for one day."

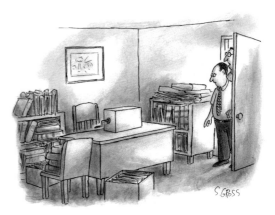

"So that's how he's able to crank the stuff out."

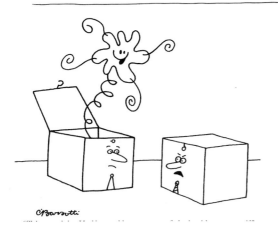

"Take my advice, Haskins, and keep your out-of-the-box ideas to yourself."

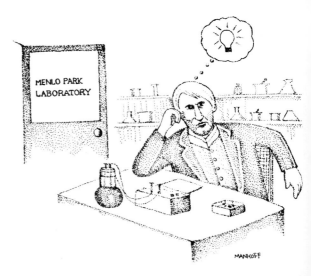

The demands on creativity made by the cartoon profession make it the ideal laboratory for studying the creative process.

Cartooning is idea creativity on overdrive. The simplified nature of cartoon ideas, the way they quickly change, mutate, breed, and evolve, make them ideal specimens of creativity. They're the equivalent of an organism like the fruit fly in genetic research.

The fruit fly is used in decoding the mysteries of the genome (fun if you've got nothing to do on a Saturday afternoon), because its chromosomes are easily seen under a microscope and because its short life cycle makes it ideal for following hereditary changes. The ideas in cartoons are like that. They're easily visible, and each of them has a life cycle whose winding course can be tracked from birth to death

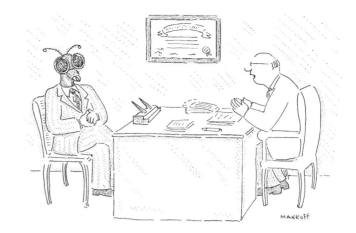

"We think it has something to do with your genome."

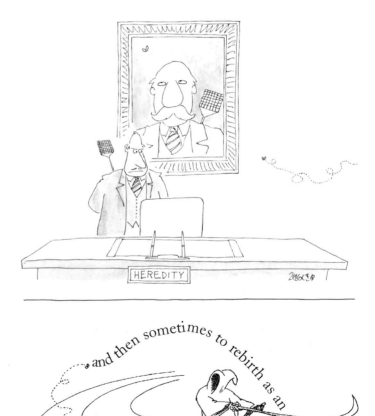

and then sometimes to rebirth as an entirely new idea.

27

In fact, the death cartoon, and its ongoing evolution in *The New Yorker,* is a perfect example.

The personification of death as a cloaked man or a skeleton carrying a scythe has long been a staple of apocalyptic illustration and editorial cartooning.

In these works, the Grim Reaper is indeed grim, but by the time he makes his way into *The New Yorker* in the late sixties, the scenario is comic, not tragic.

That's because the cartoonists have transformed him. The first change is that he's not really a symbol of death anymore. We're no longer in the land of pestilence and famine but in an America of ambition, leisure time, consumerism, and hypochondria.

"Not now. I've got too many things in the pipeline!"

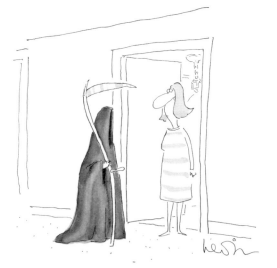

"Relax. I've come for your toaster."

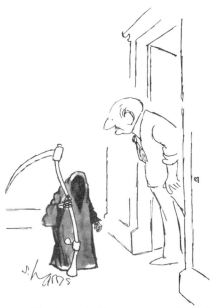

"Don't panic. I'm just a sore throat."

Once this creative transformation is made, the cartoonists play off one another's work—and their own. They see the Grim Reaper not as an alien presence but as one of us. They start to ask questions like "Just what kind of life does Death have, anyway?" Maybe he's just a working stiff working with stiffs. A guy who comes home from work like the rest of us, with even more work to do. And, if he's working that hard, maybe he needs a holiday, which maybe he can't afford.

"So I brought a little work home with me. Big deal."

So he compromises, keeps working, but kicks back, gets in a little recreation, and returns from his minivacation refreshed, with a whole new approach to his work.

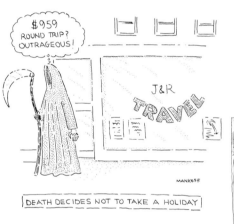

DEATH DECIDES NOT TO TAKE A HOLIDAY

Each good idea that gets published becomes part of the collective cartoon unconscious. At a certain point, a critical mass of ideas is achieved. There is then enough idea fuel to sustain a chain reaction of ideas indefinitely.

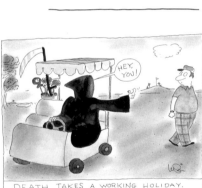

DEATH TAKES A WORKING HOLIDAY.

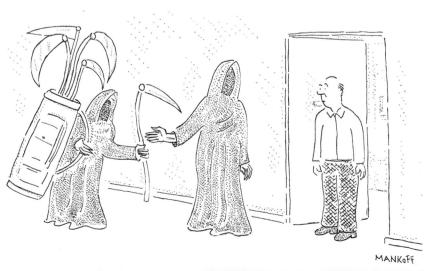

For example, in the Sidney Harris cartoon below, Death is not a tall, scary figure but an unscary, small one, as is appropriate for a representation not of death but of a sore throat.

In the "Working Holiday" cartoon he's in a golf cart, his scythe in the golf bag along with the clubs.

I recombined and reconceptualized these elements to create my cartoon, which has a smallish Grim Reaper figure acting as a caddie holding a golf bag, which is now filled with different scythe clubs.

A few more examples: Remember the cartoon with Death coming for the toaster? If you don't, have some neurological testing done, but here it is again, anyway, to jog your failing memory. It's not unusual for people to talk metaphorically about inanimate objects like flashlights, cars, and computers "dying"—nothing very creative there. But, by taking the metaphor literally and following it to a comic conclusion, Arnie Levin was able to transform common speech into uncommon thought.

Then Roz Chast's "Midlife Crises of Appliances" could build on Arnie's idea by imagining that if appliances can really die, they can be subject to life's vicissitudes as well. She had as a precedent not only Levin's cartoon but many others, like those of Jack Ziegler, in which the line between people and appliances has become quite blurry. In cartoon creation, as in all creation except the divine, there is always precedent. Everyone has that precedent to look at, but a real cartoon is

created by looking beyond what everyone else sees to find what no one has yet imagined.

So here it is: the essential nature of a hyper-creative process like cartooning. It is creativity stripped down to its essence, because it is removed from the real-world constraints that would hamper it in other fields like science or medicine. There's no reality testing in cartoons, because the mind is creating its own reality.

In cartooning, the mind changes what isn't into what is. (Death isn't a person, but, presto chango, once I draw him on a page he is. And now he's available from central cartoon casting to be transplanted into an infinity of other environments.) The digressive nature of the cartooning mind, the comic mind—my mind—thrives on this. This is the creative process, unconstrained, running amok. Don't be concerned, though. That's just its normal cruising speed, so hop on board!

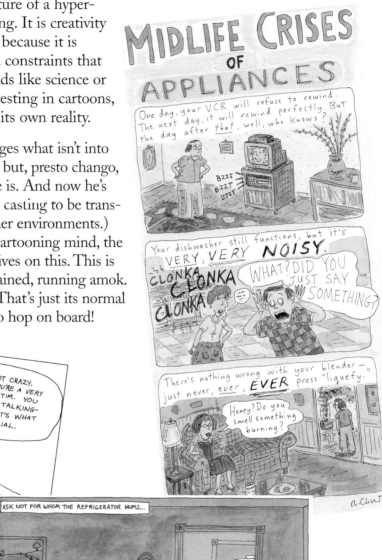

3 Idea Land

Getting ideas is like getting a loan. If you already have money, it's easy to get more. Likewise, if your mind is already stocked with ideas and associations, more are likely to come your way.

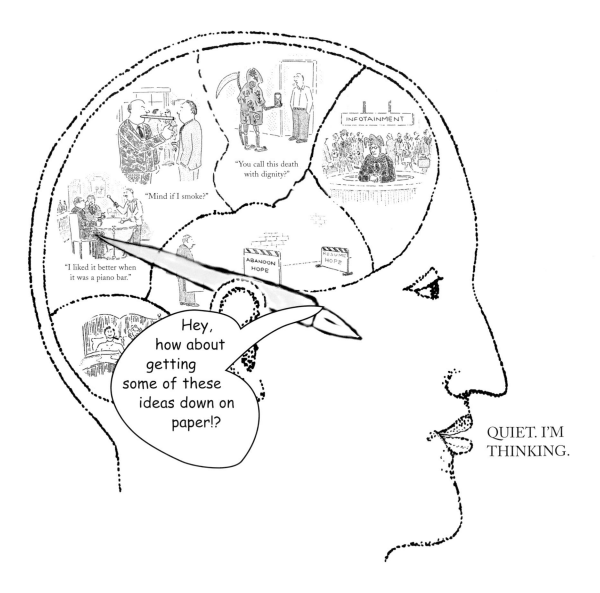

QUIET. I'M THINKING.

Ideas enlarge the mind, and once the mind has been stretched, it never goes back to its original size.

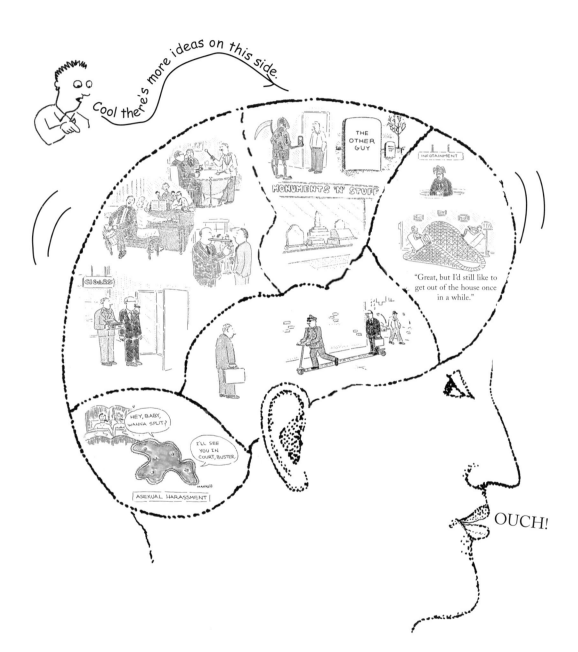

These ideas will then spark ideas of their own.

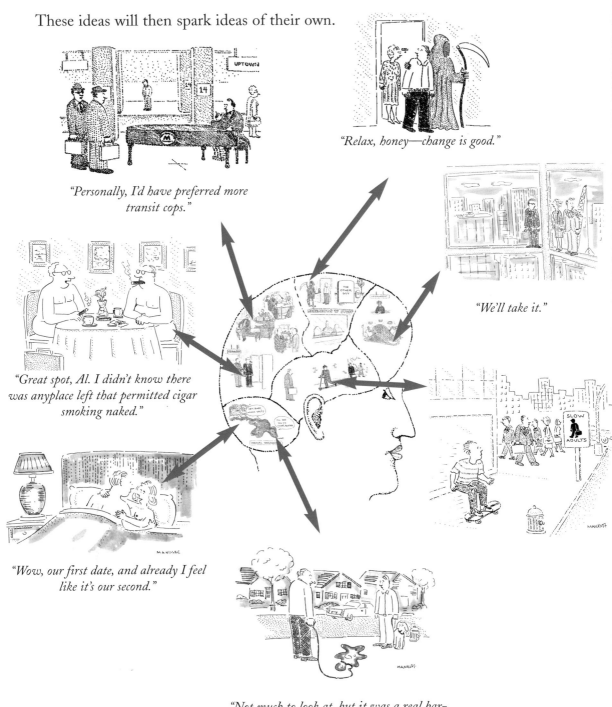

"Personally, I'd have preferred more transit cops."

"Relax, honey—change is good."

"We'll take it."

"Great spot, Al. I didn't know there was anyplace left that permitted cigar smoking naked."

"Wow, our first date, and already I feel like it's our second."

"Not much to look at, but it was a real bargain at the Gene Depot."

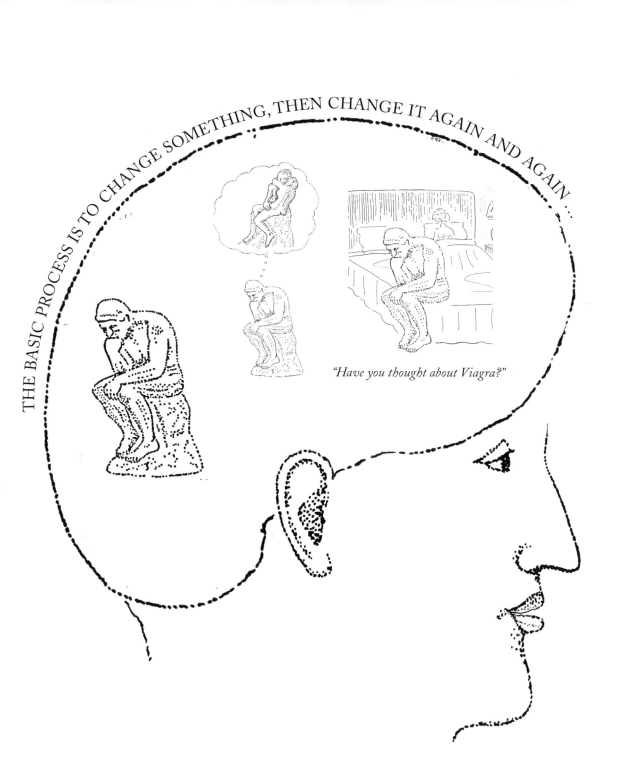

THE BASIC PROCESS IS TO CHANGE SOMETHING, THEN CHANGE IT AGAIN AND AGAIN . . .

"Have you thought about Viagra?"

Other artists may then come along
and change your changes.

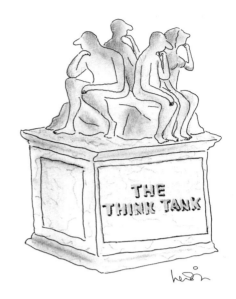

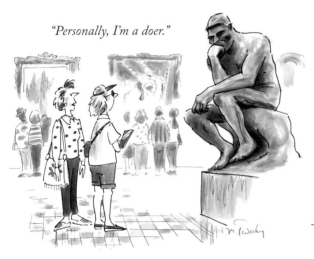

"Personally, I'm a doer."

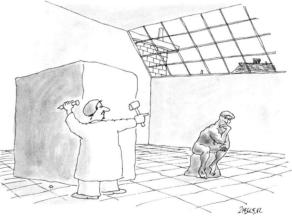

"Hold that thought."

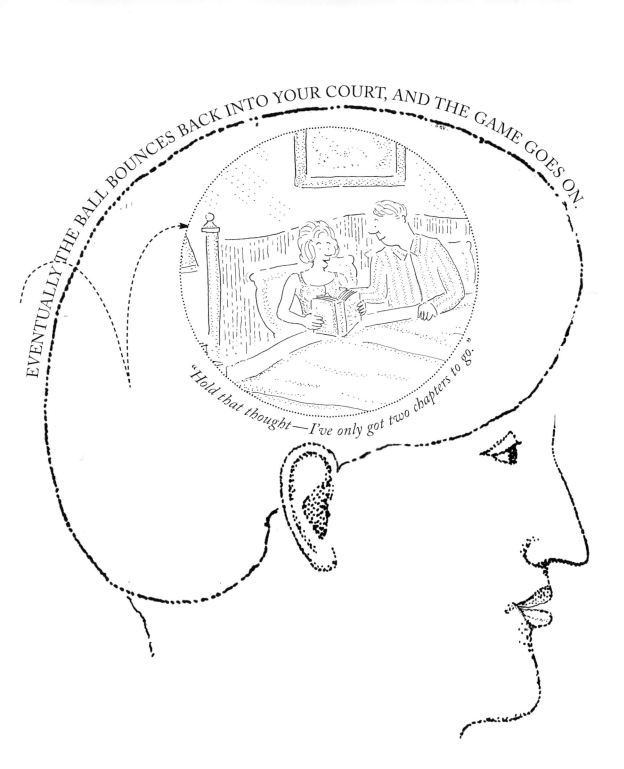

EVENTUALLY THE BALL BOUNCES BACK INTO YOUR COURT, AND THE GAME GOES ON.

"Hold that thought—I've only got two chapters to go."

But sometimes it's even simpler. An idea pops into your head fully formed, with no intermediate steps. These cartoons tend to owe more to the unconscious than to the rational mind.

Some of them owe so much to the unconscious that they actually come to you while you *are* unconscious—actually asleep. This cartoon came to me in a dream:

"Operator, get me my hair!"

Come to think of it, sleeping, dreaming, daydreaming, and napping seem to be of particular interest to cartoonists, judging by the number of cartoons that I've seen on the subject. Here's a small sample:

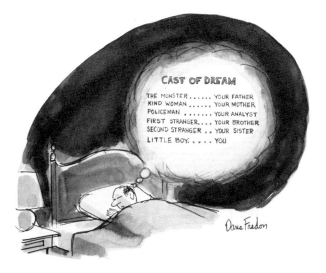

"This isn't a hasty decision. A lot of
daydreaming went into it."

"I have this recurring dream about
reclining on a bed of wild rice."

"I'd like to remind you again, Winfield, that daydreaming
is only a part of the creative process."

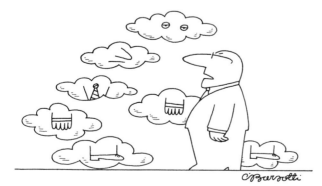

FIRST-PERIOD ALGEBRA

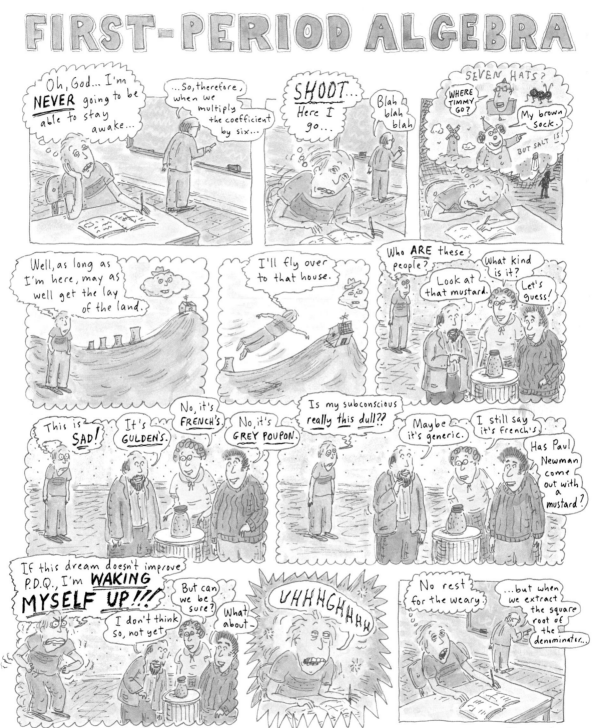

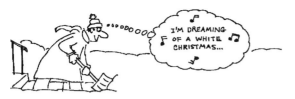

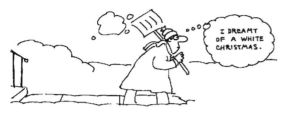

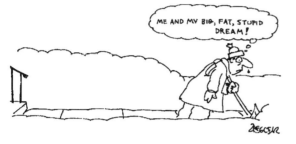

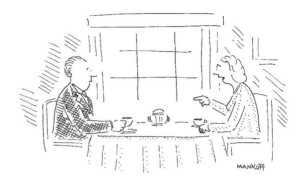

"Look, don't try to weasel out of this—it was my dream, but you had the affair in it."

This fascination suggests that the dreaming process, which collects the ordinary material and experience of our waking lives and, through the mechanisms of association, distortion, and exaggeration, transmutes them into something strange and new, is analogous to what cartoonists do when they're awake.

Actually, only about three inches. But, uh, how come you're black now?

Fine, fine. And look, if you don't understand what I'm saying about dreaming and creativity now, you will. Just sleep on it.

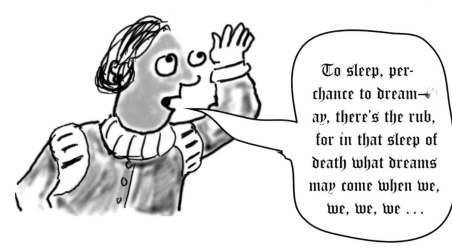

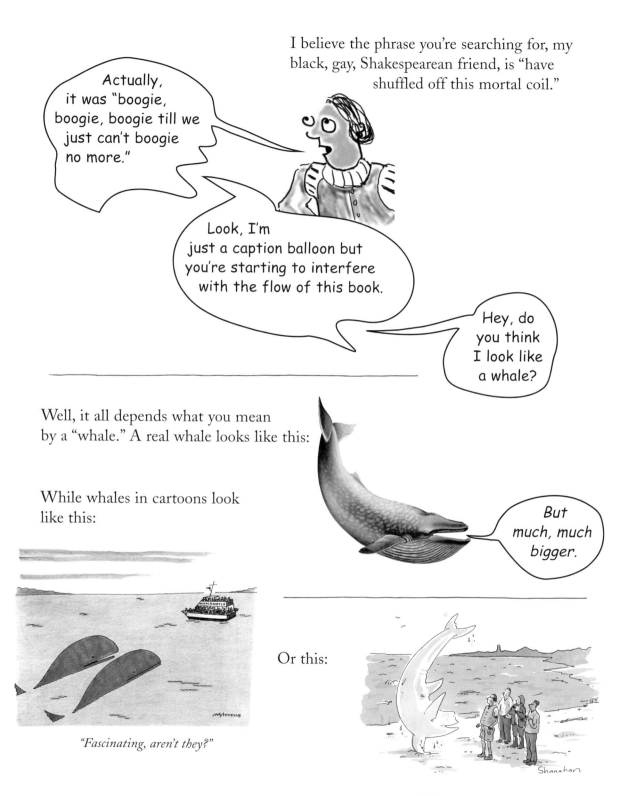

"Fascinating, aren't they?"

"If I were beached, could I do this?"

Or even this:

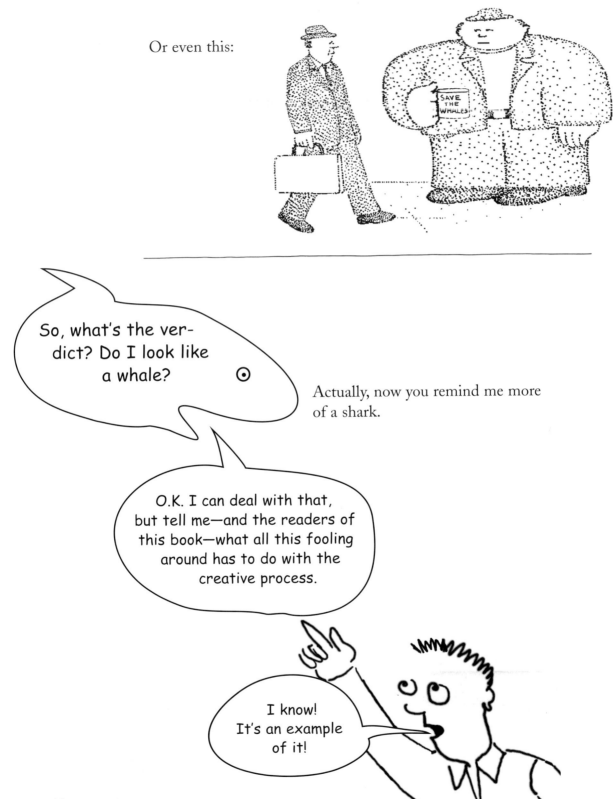

So, what's the verdict? Do I look like a whale?

Actually, now you remind me more of a shark.

O.K. I can deal with that, but tell me—and the readers of this book—what all this fooling around has to do with the creative process.

I know! It's an example of it!

Oh, I'm sorry. I seem to have dozed off. I had the most delightful dream. It reminded me of this cartoon.

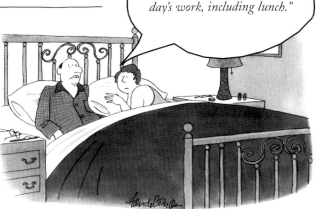

"I don't think I'll go in today. I just dreamed a whole day's work, including lunch."

Because I dreamed that I dreamed this whole chapter and, in a way, I did. Because creating is (are you ready for this?) dreaming while you're awake. A dream is the best model for pure idea creativity that I know. When you're dreaming, one part of your mind is telling a story, complete with images, to another part of your mind. Author, actors, and audience are all in the same head—yours. And even though you, the author, are creating it, you, the audience, don't know what's going to happen next.

BRAVO!

So the creative process—that is, making new things out of old thing—is very much like dreaming. In a dream, it happens naturally. The unconscious cannot help but take old material and fashion it into new forms. It is characteristic of dreams that they rarely repeat themselves. Each new day provides new material to transform.

On the other hand, in our waking, everyday state we are always repeating ourselves, reaching for the familiar, the habitual, the ordinary.

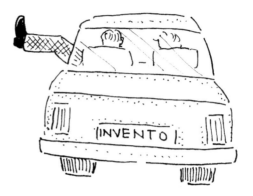

This makes sense. We don't want to be creative when we're making coffee, going to the supermarket, or driving a car. The world would not be a better place if people started inventing new ways to signal a left turn. Common, everyday tasks require common, everyday thought patterns.

But uncommon tasks—coming up with cartoons, for example—require uncommon thought processes. They require creativity. Are you following me?

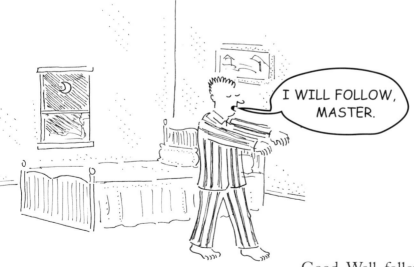

I WILL FOLLOW, MASTER.

Good. Well, follow me to the next page.

The creative process involves exaggeration, distortion, and chains of tangential association linked to our basic emotions and desires. These emotions and desires are often hidden from us; to unleash them we have to interact with reality, not as we do in everyday life, through our conscious activity, but in a warped way, as we do in dreams. Our conscious experience of reality demands action and inhibits the flights of fancy that are the soul of creativity. When we're dreaming, all activity is stripped away except mental activity, which goes into overdrive. When we're dreaming, the outside world (which we manipulate with our conscious mind) is inaccessible to us, while the unconscious world completely dominates. But when we're awake, the reverse is true. That is, unless you're a cartoonist. Then, burbling up from the unconscious, come ideas like these:

"Fusilli, you crazy bastard! How are you?"

SWISS ARMY COUCH

"Don't worry. Fantasies about devouring the doctor are perfectly normal."

Everything about these cartoons is wrong, at least from the perspective of "reality." And yet they somehow strike us as entirely sensible, if not exactly reasonable, because they connect with the center of our emotional reality—our unconscious.

Cartoons aren't exactly real—surreal would be more like it. As these images from the surrealist school, juxtaposed with related images from the cartoon school, demonstrate:

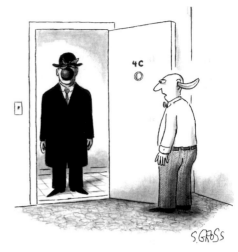

"Oh, it's you."

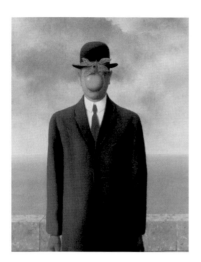

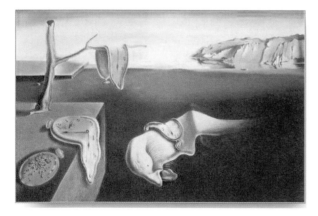

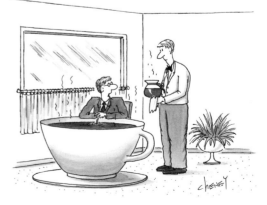

"No thanks, I'm fine."

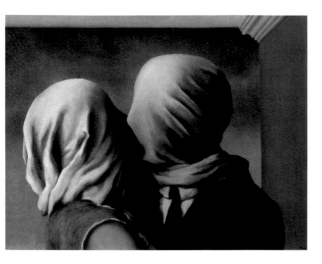

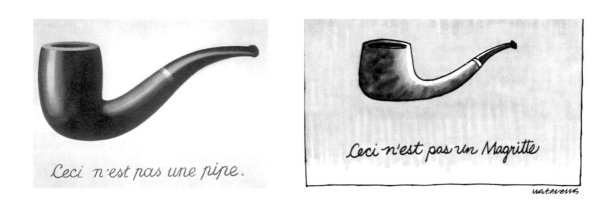

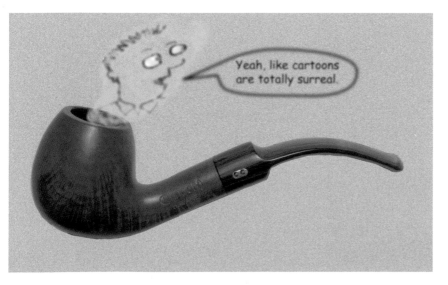

But even surrealism isn't an exact match for cartooning. Because, where surrealism tends to be anti-rational, somber, and even downright ominous, cartooning trawls the unconscious primarily for laughs. Surrealism does not attempt to resolve the incongruities it creates—it revels in them. Cartooning, on the other hand, creates revelry by making the incongruous congruous through creative logic. While this process is not exactly Aristotelian, it does make sense out of what would otherwise be nonsense.

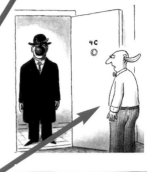

Very few people would agree on what this picture means, or who this guy is, but we all know who *this* guy is. The crazy logic of Sam Gross's cartoon has made it clear. Mr. Banana Ear is Mr. Fruit Face's friend.

Gross uses the same experimental thought procedures we saw employed earlier in the Grim Reaper cartoons. There, the cartoonists imagined a suburban existence for the medieval figure of Death. They took him out of one context, put him in another, and let the associative logic of cartooning take care of the rest. Gross has done the same thing for the Magritte character. Once he has freed him from his original context, other cartoonists, like Michael Crawford and Ronald Searle, can start to imagine him in new settings, too.

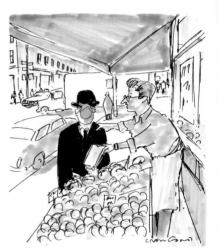

"Sure I can't pop that in a bag for you, sir?"

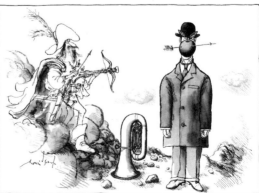

CROSSED PATHS
William Tell Meets Magritte

In fact, anyone is now free to clone him at will for their own purposes—even me.

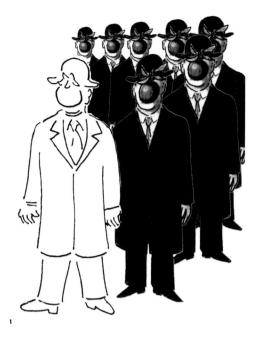

What might these purposes be? Well, we might put him in a support group of people who are stigmatized by fruit, along with banana-in-the-ear man and cucumber-coming-out-of-my-nose woman. The basic mechanism of cartoons is to start asking the "what if" question.

"What if" takes us away from the boring and restrictive "what is" into the realm of creativity. The "what if" technique is one of the most effective ways I know for exploring creative possibilities. Before we see what it can do for this guy, I think it's worth exploring what it's done in other situations.

For example, What If . . .

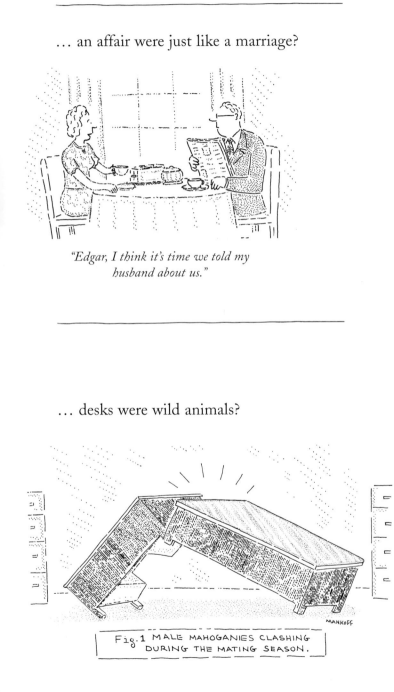

... an affair were just like a marriage?

"Edgar, I think it's time we told my husband about us."

... desks were wild animals?

Fig. 1 MALE MAHOGANIES CLASHING DURING THE MATING SEASON.

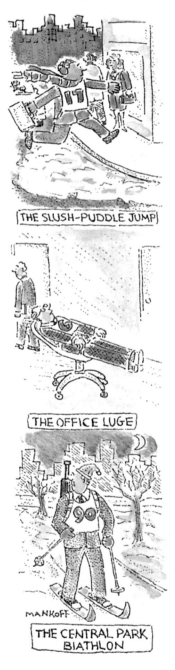

... New York City had a Winter Olympics?

THE SLUSH-PUDDLE JUMP

THE OFFICE LUGE

THE CENTRAL PARK BIATHLON

... fish were philosophers?

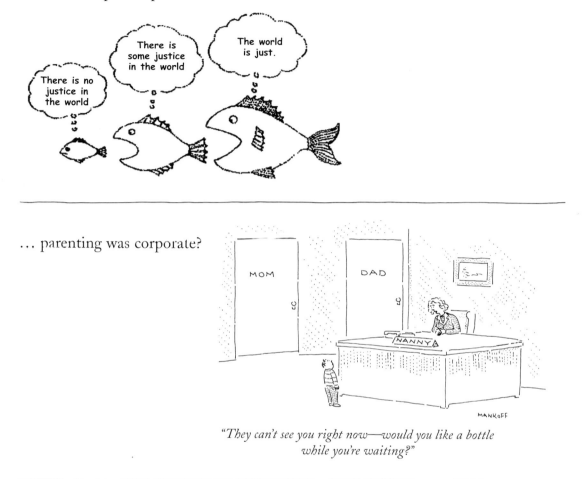

... parenting was corporate?

"*They can't see you right now—would you like a bottle while you're waiting?*"

... pigs could fly?

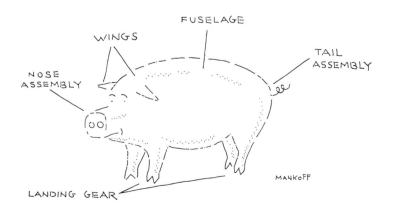

Got the idea? Great. Now let's ask the magic question.
What if ... the fruit-face guy went traveling?

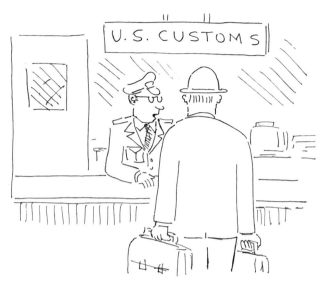

"Uh, any other fruits or vegetables to declare?"

What if he got hungry?

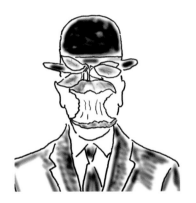

What if he became a shill for a computer company?

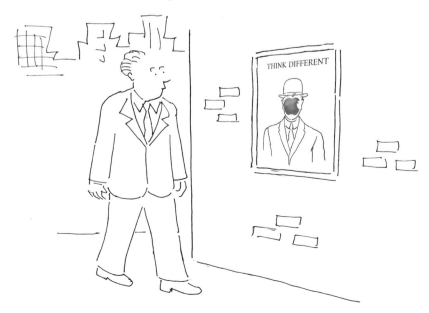

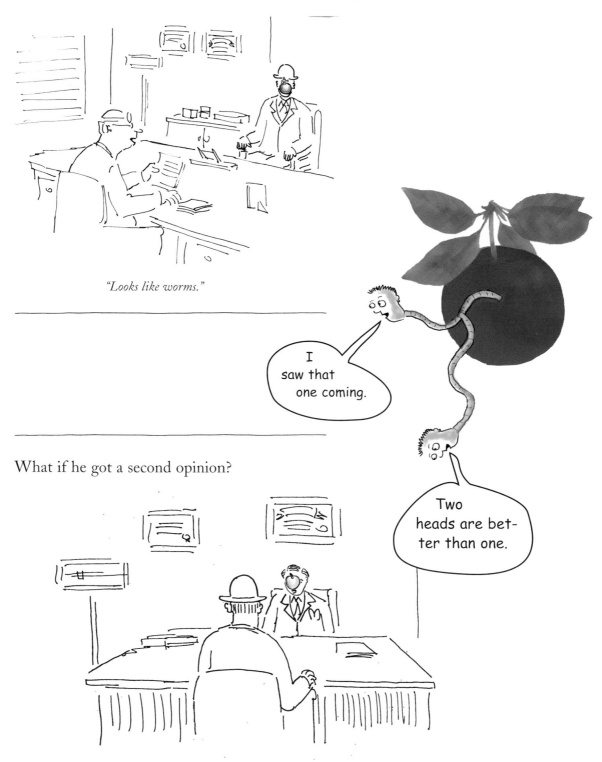

"Looks like worms."

What if he got a second opinion?

"There's nothing wrong with you–
I'm referring you to a psychiatrist."

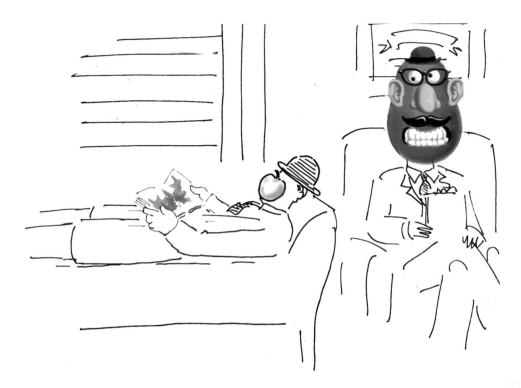

*"Why are you showing me all these pictures of apples,
Dr. Potato Head?"*

Right now, I feel like a potato head myself. I have as much idea as a tuber would about what's going to happen to my abducted Magritte character. This is bad for me, but it's good for you. Because it is only when the creative process is halted or slowed down that we have a chance to observe it. It's stopped now. So I'm forced to ask, What can I do to start it up again?

The simple answer is this: I have to combine the "what if" premise with associative techniques. But before I do that, I've got to just stare at what I've done—stare and stare and stare until I achieve complete boredom. Why seek boredom? Because boredom is your creative friend. When you're bored, you seek stimulation. If you are denied external stimulation, you're forced to make do with what's in front of you.

Pretty soon, this boredom leads to a dreamlike, hallucinatory state in which the words and images on the page swim and spin around in your head, so that you no longer see them as they actually are. They become distorted and evoke not what they are but what they might be.

Graphically displayed, the process might look something like this. Just looking at it, I'm becoming slightly disturbed and agitated, which is good. That agitating energy that comes out of boredom is often the precursor to a good idea.

Speaking of agitation, let me agitate the spin cycle (or maybe spin the agitation cycle) again and see what comes out in the wash.

Hey, now we're getting somewhere. The inkblot has spun into view. The least obvious of all the stimuli will lead to the best idea. Let's just follow its lead and see where it takes us.

Hmm, sort of looks like a face, maybe with a hat with something coming out of it. Okay, now I'm seeing with my third eye, projecting my creative needs onto this ambiguous image, and transforming the actual into the creative by letting the unconscious mate with the material from the last few pages and map out the necessary path.

Out of a disorganized whirl of fruity ideas we've created something new—a cartoon character. (In this case, she looks suspiciously like Carmen Miranda, a well-known friend to fruit.)

Now let's rejoin our book, already in progress.

*"Why are you showing me all these pictures of apples,
Dr. Potato Head?"*

Probably to try to find his innermost desires—for example, who
might be the woman of his dreams? Well, off the top of my head
(and the bottom of my mind), I can think of two excellent candidates—
Carmen, for one, Chiquita for another.

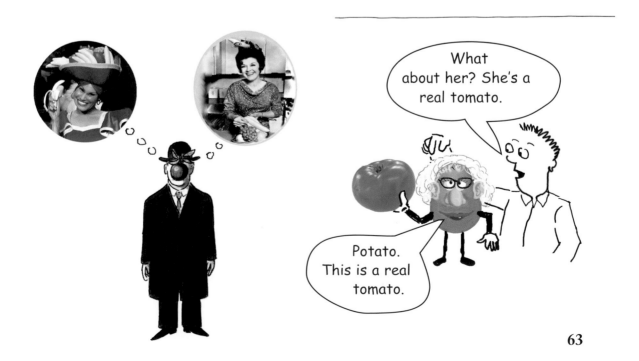

My dear deluded woman, of course it isn't a real tomato. Even though it's a fairly accurate photographic representation of a tomato, it still functions in the symbolic mental world, not the real physical world. It's just like Magritte's non-pipe—which I'm not really smoking, of course.

OH, YEAH? WELL, TAKE THAT, MR. TOMATO HEAD!

Nice try. I guess the tomato is in my court now, and the game can continue. The game is a mind game. That's the only place it can happen, because ideas occur in only one place— your head. Not in the real world, where a tomato is just a tomato, but in conceptual, associative space, where the tomato cannot be tasted in any way other than symbolically. If I have a real tomato in my hand, I'm going to worry about throwing it around. It won't inspire creative thought; it will inhibit it. But in my head and, by extension, on this page, there are no limits to what I can do with it. It's only when we take elements from the real world and put them into the unreal world of thought that the rigidity of reality can give way to the malleability of mind.

I'm drawing a distinction here between the real, on the one hand, and the unreal; the conscious and the unconscious. Your conscious mind isn't just restricted by reality; it is actually inhibited by it, which is why it's hard to use creatively.

Reality, brought to you directly by your senses, tends to be the endpoint for the conscious mind, but the starting point for the creative or unconscious one. That's why when creative people do their work, they isolate themselves from real-life experience.

It's no accident that when people want to get an idea they close their eyes and shut out the real world. They want to be stimulated by what's internal. They know that no matter how hard they look at the outside world, or how intently they listen, their eyes and ears can't help them.

When I put a tomato in front of you, it takes the textbook path from your eyeball to your optic nerve and then to your brain. When I remove the tomato, you no longer see it with your eyes. But a mental tomato is still there to be dredged up when you need it for anything but eating. However, what pops up from the brain soup when you call upon it can be a very unpredictable thing, because the tomato that went in through the senses often isn't anything like the tomato that comes back out by way of the unconscious.

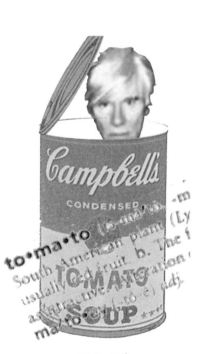

pop art
Campbell's Soup I (Tomato),
1968, by Andy Warhol

When I review the creative chain of associations and transformations that produced that last image, something interesting happens.

New and unexpected images emerge. The creative process keeps transforming its own material. When I rewind the tape to see what was on it, I change the tape. If I were to rewrite (or, maybe more accurately,

reimage) this book so as to just create something interesting rather than to explain what I'm creating, I would change the two images on page 65.

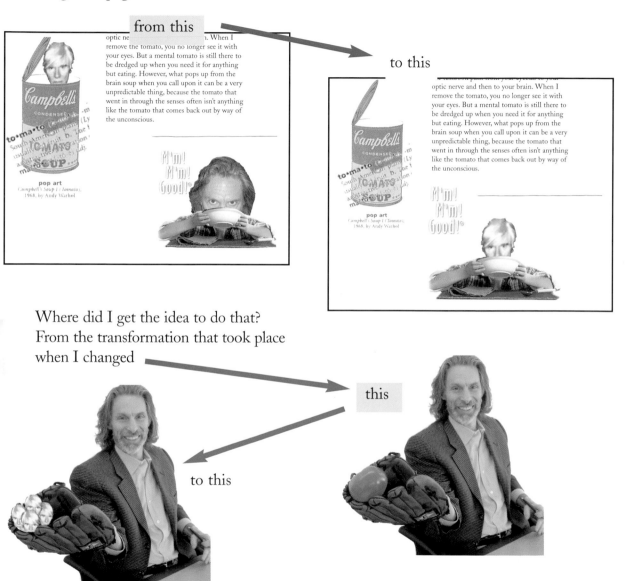

from this

to this

Where did I get the idea to do that? From the transformation that took place when I changed

this

to this

The tomato in the baseball glove has now changed into a bunch of Andy Warhol heads, because between the creation of the two glove images, I created the image of Warhol's head popping out of his pop-art soup can. It was so much fun pasting Andy's head into the baseball glove that I pasted it into the soup picture as well.

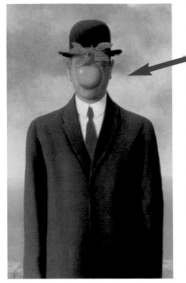

This section of the book started with Mr. Appleface, and it might well conclude with the transformed Mr. A. It's a Warhol tomato-face instead of Magritte's original, which makes perfect sense in the context of these pages. It was neither inevitable nor predictable. That's what makes it creative. It is unique because of the process that produced it; the natural cycle of creativity is essentially uncontrollable and will always produce unusual, unpredictable results. The unconscious mind transforms conscious experience, producing an idea that then evolves, through concrete, conscious activity (drawing, computer manipulation, etc.), into something real and not easily manipulated (a picture on a page). Now, what can I do with this physical object, this piece of paper with ink on it?

Not much, really, except mangle and mutilate it.

But, in time, what's on the paper leaves an imprint in the unconscious that is much more significant than the conscious visual impression. In the unconscious, it has no physical constraints or limitations. It can change and be changed when it meets up with other similarly unconstrained mental entities.

Because of this process, if I were to set out to re-create this section, it wouldn't, couldn't, and shouldn't be the same. Only if I *consciously* copied the section, and repressed my unconscious, could I duplicate it exactly. The unconscious is bound to intrude and change something, maybe just a little something, which in turn will change something else. It will end up like those sci-fi stories where someone travels back in time, steps on a butterfly, and thereby changes the entire course of the planet.

The journey of creativity is one in which you know where you're going only when you get there. And then, of course, it's time to move on.

Hey, my bags are packed.

Unpack 'em. You won't be going anywhere.

Why not?

CREATIVITY OR BUST!

BECAUSE YOUR FIFTEEN MINUTES ARE UP.

4 Counterfactuality

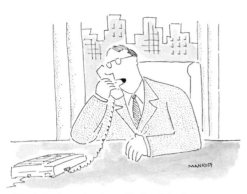

"Let's look at the facts, Sedgwick: daily news-paper circulation is lagging behind population growth, gas was first used in 1915 to break the trench-warfare stalemate, the cassava is fast becoming one of the world's most important tubers, and finally, for God's sake, Sedgwick, apes have nails, not claws!"

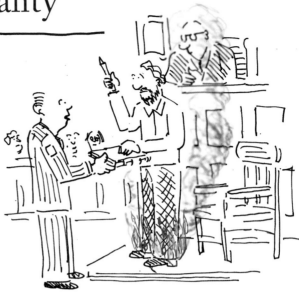

"Do you promise to tell the truth, the whole truth, and nothing but the truth notwithstanding the fact that your pants are on fire?"

The facts? Boring. The truth and nothing but the truth? I don't think so—too restrictive. I couldn't do any of my "what if" stuff. Frankly, I'd much rather lie. Bad for the soul, but good for the creative brain. Lying is very creative. When you lie, you "make something up." If you do it well, you can get others to believe you even if what you say is absurd. Lying about reality is hands-down the best method of creating cartoons.

We cartoonists do it as soon as we start drawing. That scene of me above, on fire? I made it up. Even what it depicts, like Magritte's pipe, isn't really there. No court-room, no fire, no me, no nothing. Just ink.

So that's yet another big secret of coming up with cartoon ideas. Lie. The bigger the lie, the better, but start off with small ones if you're uncomfortable. And if you're uncomfortable with the term, then call it "counterfactual creativity," which simply requires simultaneously creating the real and the unreal, the possible and its opposite. This duality, and the tension it creates, is the engine of creativity and humor. Once you accept it and get comfortable with it, you start to disable the rational processes that inhibit creativity. And you start to develop the processes that encourage creativity.

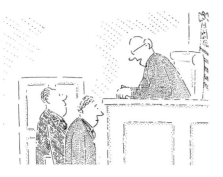

The rational mind is perfectly happy with a picture like this, but once the unconscious starts to blur, twist, twirl, free-associate, and falsify it to its liking, the conscious mind balks, declaring, "Hey, I'm outta here. I've got things to do—your taxes, shop for groceries, whatever—and if you've got time to waste on such nonsense, well, you're on your own."

But where the rational mind is appalled, the irrational mind is intrigued, and goes to work. It thinks, Interesting. Guy upside down. What's going on? Why is this guy upside down? No gravity? No problem. But it's a problem for the guy,

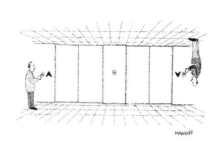

because he's in a court of law and he's clearly violating the law of gravity. How about having the judge say, *"Counselor, please advise your client that, issues of personal safety aside, gravity is the law."*

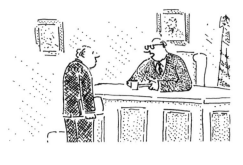

Okay. Now let's take a look at this picture. What's wrong with it? Nothing, and that's exactly what's wrong with it. It's absolutely ordinary, so our conscious mind is perfectly content. The caption might be something like "Counselor, please call your witness," which is clearly not the caption we're looking for.

What is missing is the duality, the clash of the ordinary and the extraordinary that we need to stimulate creativity. As we've seen, a primary way to achieve that in cartooning is by transforming an ordinary image into an incongruous one. This produces a dissonance that the right caption or title can resolve.

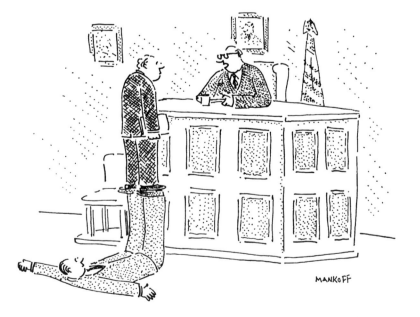

"Be advised, Counselor, the court will not tolerate a circuslike atmosphere."

And there is a "right" caption, because the process is not completely random. While there's madness in the method, it's not so crazy that it loses touch with its own unreality. That's why you won't have any problem matching these randomly arranged cartoon incongruities with their appropriate captions.

A. *"Jeffrey makes all our furniture himself."*

B. *"Dear, do you think you may have become too comfortable with your masculinity?"*

C. *"Personally, I liked this place better before it became a sports bar."*

D. *"Damn! I forgot to disconnect my personal alarm system."*

E. *"Brad, we've got to talk."*

F. *"Now, that's product placement!"*

G. *"Davis, come in here and take a bullet."*

H. *"Say what's on your mind, Harris— the language of dance has always eluded me."*

I. *"I think I'll pass—I'm having a really bad-nose day."*

J. *"Geez, you're the worst focus group I've ever seen."*

K. *"Here's the artist's conception of your proposed smile."*

The matching exercise is reminiscent of the caption contests we run every year in *The New Yorker*, where we ask readers to think like cartoonists. In the 2000 contest, we furnished this drawing by Danny Shanahan, which has nearly everything you could want in a cartoon—a stubbly geezer, a young nurse, a creepy ogre lurking in the doorway. But there is one thing missing: the right caption to make the whole thing funny.

Every cartoonist knows that the temporary warping of reality that drives a cartoon is hard to pull off even when you're in full control of both the picture (with its delicate balance of characters and props) and the caption (which demands rhythm, brevity, and surprise). So it seems particularly daunting to try to create a good cartoon when one of the elements is completely out of your control.

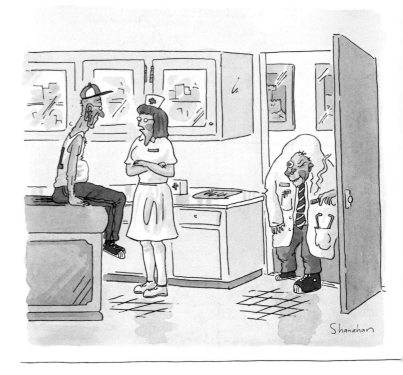

Yet the creative mechanism of incongruity and counterfactuality that I've been illustrating clearly worked its magic, in this case. Thousands of readers looked at the picture and saw what wasn't there: nineteenth-century literature, our current health-care mess, or the medical breakthroughs that promise to transform and terrify us. The wide range of associations triggered can best be plotted through a computer analysis of frequently occurring key words in the captions.

H.M.O. (1001), Notre-Dame (484), hunch (298), Quasi (234), side effects (232), eye (212), Dr. Igor (205), bells (203), Viagra (202), plastic surgeon (195), ear (191), ringing (184), Quasimodo (112), drugs (100), gene (99), Dr. Frankenstein (88), transplants (81), Dr. Jekyll (79), Dr. Modo (77), organ donor (75), medication (71), brain (63), tinnitus (52), Mr. Hyde (49), Paris (49), Bush (47), Gore (44), Esmeralda (42), radiology (41), Hunchback (39), Hugo (39), hiccups (35), France (35), Transylvania (23).

But, no matter how "scientific" we want to be about it, no computer could ever come up with captions like these:

a) *"The gene therapist will see you now."*

b) *"And be sure to tell him about the ringing in your ears."*

c) *"It stands for Hideous Myopic Ogre."*

d) *"Parlez-vous Français?"*

e) *"You'll feel better when you see the doctor."*

f) *"Don't open your eyes until I tell you. The doctor has cured thousands of cases of hiccups."*

g) *"Not to worry—Dr. Igor will make a new man out of you."*

h) *"Meet the face behind the Home Laser Eye Surgery Kit."*

Like any of these? We picked (e), but I can see your point.

In the 2001 caption contest, Frank Cotham supplied the provocative image. More than 2,300 entrants were stimulated enough by it to attempt to create some counterfactual world to explain it.

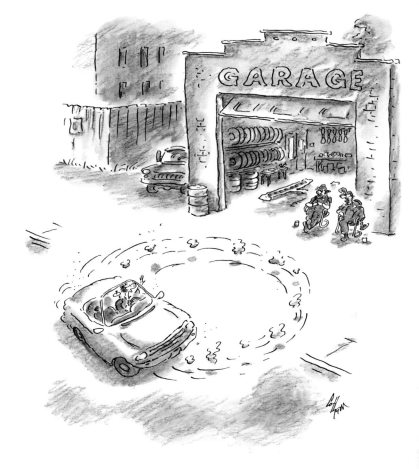

Some readers imagined that the car had been overcorrected from a permanent clockwise spin. Others suggested that it was under the spell of the Coriolis effect, which explains the influence of the earth's rotation on moving objects. The captions that didn't focus on the car focused on the two mechanics. Along with captions proposing churlish mechanics and clownish mechanics, we received entries with philosophical mechanics (*"I am reminded that the pleasures of life, like those of travel, lie in the journey rather than the arrival"*), and malicious mechanics (*"Come on, just tell him you hear the noise"*). In a few entries, the mechanics were absurdly specific in their diagnosis (*"Either he's got right-occipital-lobe hypertrophy complicated by a limbic-system imbalance or his wheels need realignment"*).

Other noteworthy entries included:

"Runs like a top."

"C'mon, Al. Quit hogging the remote."

"At what point does this become 'our' problem?"

"I'm thinking mad-car disease."

"No, not yet. A couple more hours of that and his warranty will expire."

"I'll unjam it when his credit card clears."

"... or it could be a bug in the ol' global positioning system."

"I told you he'd notice."

"I fixed the transmission, but he was too cheap to pay for the inner-ear work."

"Of course, in Fiji this would be an entirely different problem."

Had Frank Cotham and Danny Shanahan come up with the images below, instead of the ones they did, nothing would have been stimulated but our readers' annoyance. A caption contest can't just consist of a drawing in which two people are talking to each other, because anything could be said. Paradoxically, this stimulates nothing interesting at all. The caption is the last piece of the puzzle—but it does require a puzzle.

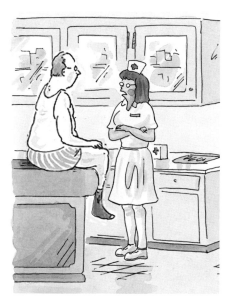

In the same way, if I drew A rather than B,

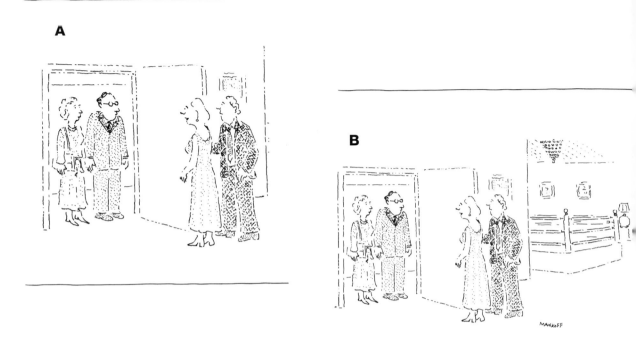

A

B

there would be no puzzle to solve. So the caption *"You two wrestle, don't you?"* would go to waste. Picture C doesn't need *"Will the owner of the car with license 417-JHL please move it?"*

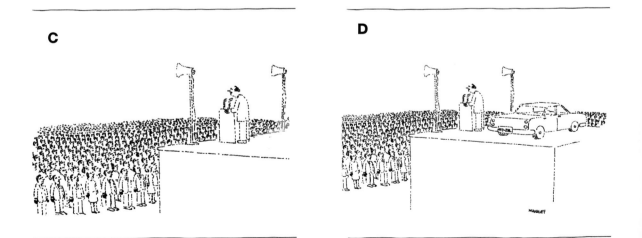

C

D

There are, of course, other approaches to constructing a pleasingly funny cartoon. You've got to be creative about creating creativity.

Sometimes the false premise about the world you create originates in the caption or title, which does most of the work, and the picture is quite mundane. The labeling transforms what we are looking at, taking it from one realm into another. Once the unlikely words are applied, the picture becomes not part of our world but part of a parallel universe in which, for example, pieces of furniture strike pornographic poses.

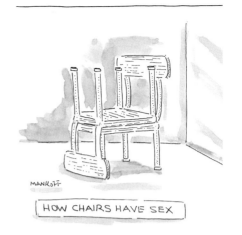

HOW CHAIRS HAVE SEX

"Mind if I put on the game?"

"No, I don't want to play chess. I just want you to reheat the lasagna."

"You think you have problems? My entire wing command was just destroyed."

"Let me through—I'm the victim!"

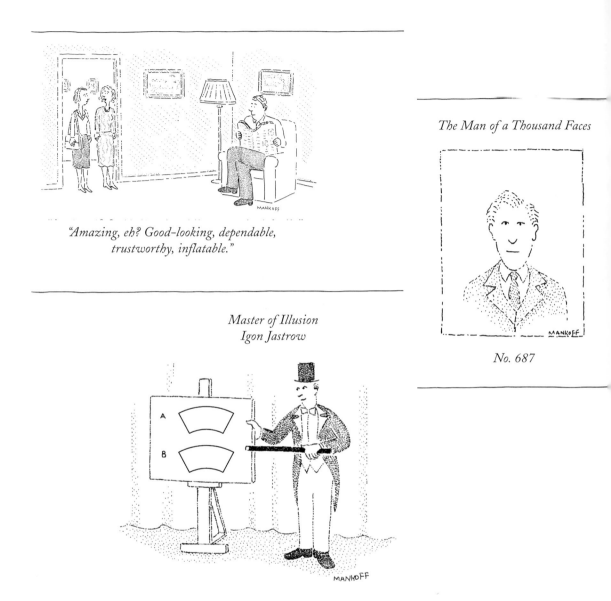

"Amazing, eh? Good-looking, dependable, trustworthy, inflatable."

No. 687

Master of Illusion
Igon Jastrow

Igon Jastrow was, pound for pound, the greatest illusionist of his era (September 1923 to November of the same year). He is pictured above during his heyday (October 3, 1923), with his famous Jastrow illusion, in which figure B appears much larger than figure A, although both figures are identical in every respect. Though Jastrow was a certified master of illusion, audiences found it hard to accept his statement that both figures were identical. Even when he had this statement notarized they remained skeptical and often demanded refunds. In fact, Jastrow could not even convince his own wife that the figures were the same size, and she divorced him when he continued to pester her about it. Ironically, Jastrow's wife won custody of the illusion while Jastrow got the children, who were identical twins. At least according to Jastrow they were identical; his wife always claimed that one was much larger.

In the previous cartoons, the words do most of the work—but without the accompanying images they wouldn't be funny. In the cartoons on this page, what I call text-centric cartoons, the image needs a particular setting but the line can basically stand by itself, calling to mind the appropriate picture.

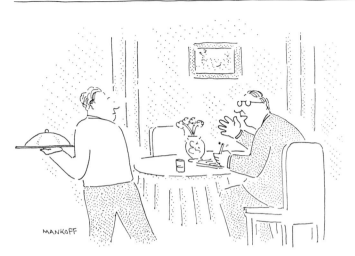

"Waiter, I'd like to order, unless I've eaten, in which case bring me the check."

"A billion is a thousand million? Why wasn't I informed of this?"

"I have no objection to alternative medicine so long as traditional medical fees are scrupulously maintained."

"On the one hand, eliminating the middleman would result in lower costs, increased sales, and greater consumer satisfaction; on the other hand, we're the middleman."

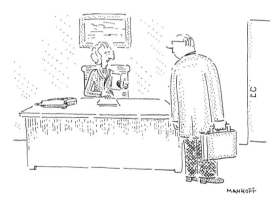

"Sir, the following paradigm shifts occurred while you were out."

"We don't believe in pressuring the children. When the time is right, they'll choose the appropriate gender."

"Pendleton, as of noon today your services will no longer be required. Meanwhile, keep up the good work."

The most extreme example of a text-centric cartoon is one in which nearly any general locale where people exchange comments will do.

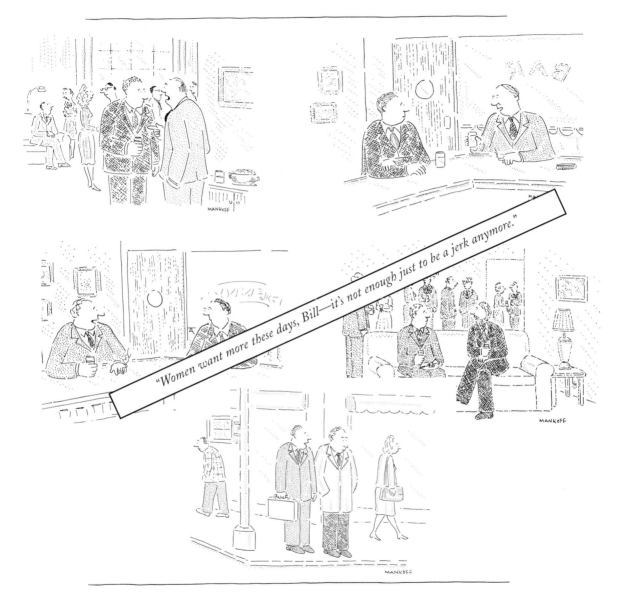

"Women want more these days, Bill—it's not enough just to be a jerk anymore."

These cartoons are really illustrated aphorisms, quips, or one-liners. They are more like stand-up routines than classic gag cartoons. In fact, I'll let my brother Shecky Mankoff deliver a few of mine, minus the images that originally accompanied them, to show you how well they work without the pictures.

"See, the problem with doing things to prolong your life is that all the extra years come at the end, when you're old."

"Pushing fifty isn't the problem—it's pulling forty-nine."

"At this point, my privacy needs are interfering with my intimacy goals."

"And, while there's no reason yet to panic, I think it only prudent that we make preparations to panic."

"Me and my publisher are still pretty far apart. I'm looking for a six-figure advance and they're refusing to read the manuscript."

"Oh, I guess I'll remarry someday. But first I've got to demarry."

"Instead of waiting for the next big thing to transform my life, I'm thinking of giving it a shot myself."

"Frankly, I've repressed my sexuality so long I've actually forgotten what my orientation is."

"I don't want to live forever, but I damn sure don't want to be dead forever, either."

"In the future, everyone will have privacy for fifteen minutes."

"One question: If this is the Information Age, how come nobody knows anything?"

"Look, I can't promise I'll change, but I can promise I'll pretend to change."

"I'm a citizen of the world, but I'm based in Bayonne."

"Call it denial if you like, but I think what goes on in my personal life is none of my own damn business."

"Look, children are just pathetic substitutes for people who can't have pets."

"Y'know, I don't know what I'd do without her, but I'd sure like to find out."

"Hey, I've got nothing against globalization, just as long as it's not in my back yard."

"All I'm saying is that if God created man in his own image he was a bit of a cloner himself."

But seriously, folks, there's nothing wrong with the one-liner, two-liner, or even three-liner, but I have a fondness and a weakness for cartoons at the other end of the continuum, where words have no importance at all because there aren't any.

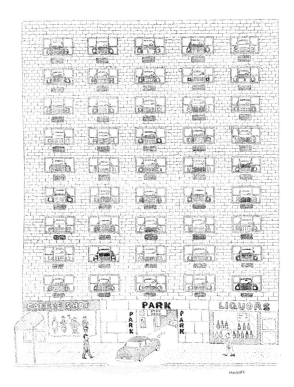

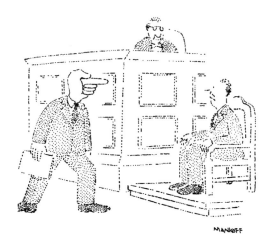

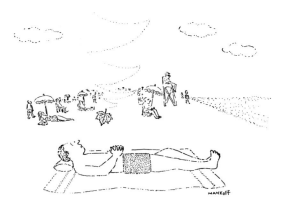

"Do you think you could give me a hand? The guests will be here any minute."

"O.K., but change 'Her tawny body glistened beneath the azure sky' to 'National problems demand national solutions.'"

But, whether it's unusual pictures with commonplace phrases, ordinary scenes accompanied by sentences real people would never utter, strange images with stranger words, or wordless visions of impossible worlds, the problem for the cartoonist is to come up with the stuff.

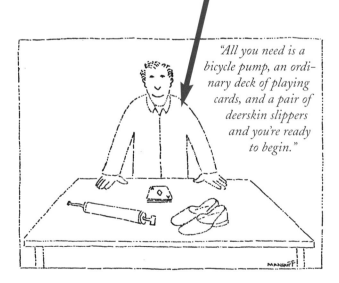

"All you need is a bicycle pump, an ordinary deck of playing cards, and a pair of deerskin slippers and you're ready to begin."

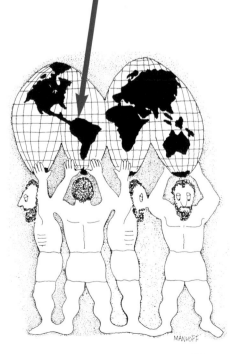

That's the basic creative problem, of course. It's the problem that these cartoons solve by blending, combining, and blurring two or more different situations into one.

Most cartoons or funny ideas have this weird combining aspect. It is a conceptual blending and overlapping of categories that the normal, conscious mind resists, but that is absolutely necessary to create new ideas. A provocative way to think about it is that it is as if a couple of ideas and concepts got together and had sex. Out of this conceptual intercourse, new ideas are produced that are more than the sum of their parts. They must be concepts that have some affinity, some similarity, some chemistry between them. No attraction, no sex.

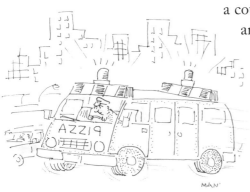

In the real world, thankfully, there are no vehicles like this one. Creativity starts when we start to look for mates. The cartoonist plays the matchmaker. As matchmaker, I'm influenced by other successful matches I've made before.

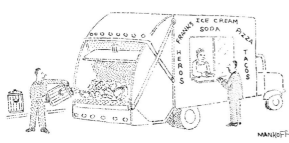

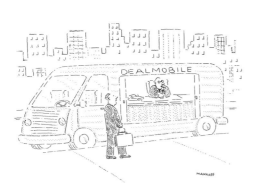

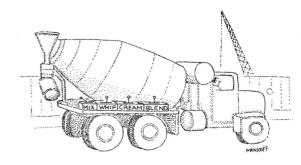

Once I introduce two ideas to each other, I don't know what's going to happen. Maybe I'll spark a long-term relationship or just a one-night stand, but even if ideas are long-term, they're never monogamous. They're promiscuous, perverse, hetero- and homoconceptual.

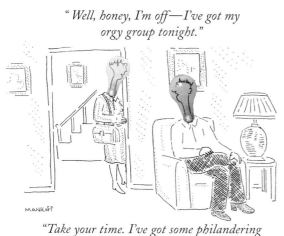

"Well, honey, I'm off—I've got my orgy group tonight."

"Take your time. I've got some philandering lined up for later tonight myself."

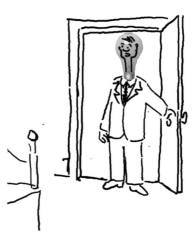

"My wife, my best friend, my best friend's boyfriend and his parrot—cool!"

This caveman might be completely happy sitting in a modern living room, but before you know it he and all the concepts he embodies are gallivanting into another venue.

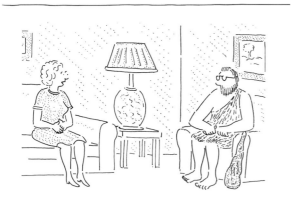

"Dear, do you think you may have become too comfortable with your masculinity?"

"We feel that your female characters are somewhat undeveloped."

As it turns out, mythical prehistoric iconography combines naturally with the language of psychoanalysis or of literary criticism.

In the same way, the idea of "personal classifieds" makes a good match with the generic introduction cartoon, as shown here:

"I think you two may hit it off. Craig, here, is an attractive male academic in his early forties who seeks a warm, vivacious woman delighting in conversation, the arts, and nature for an evolving romantic commitment, possibly marriage, while you, Vivian, are a good-looking, intelligent, stimulating woman in her late thirties who seeks an educated, unattached, well-bred man concerned with ideas, culture, and the environment with whom to share your life interests and companionship."

Then it could dally with the "up close and personal" way we deal with sports figures, before settling down, for a while, in the domestic bliss of the "His and Hers" towel cartoon format.

"Ken bats left-handed, enjoys cultural as well as outdoor activities, and seeks a sensitive nonsmoking woman for a lasting partnership that includes long walks, good music, and fielding practice."

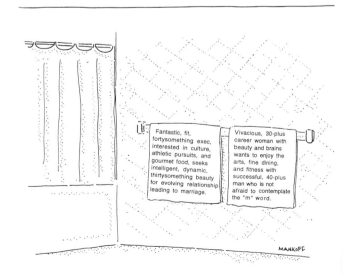

Fantastic, fit, fortysomething exec, interested in culture, athletic pursuits, and gourmet food, seeks intelligent, dynamic, thirtysomething beauty for evolving relationship leading to marriage.

Vivacious, 30-plus career woman with beauty and brains wants to enjoy the arts, fine dining, and fitness with successful, 40-plus man who is not afraid to contemplate the "m" word.

In a way, this combination approach is like the old children's jokes that go something like "What do you get when you cross a gorilla with a parrot?" In reality, you can't combine these things, but in our imaginations there are no barriers. The following cartoons reply to the "What do you get when you cross" question:

What do you get when you cross a well-known literary group with a game show?

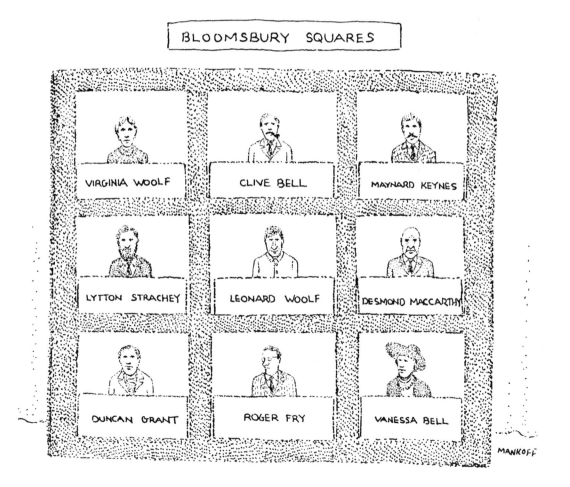

What do you get when you cross a game show with the legal system?

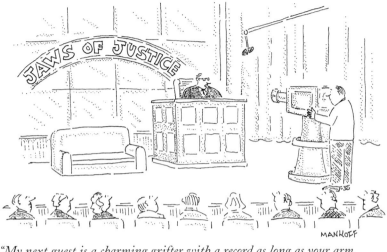

"My next guest is a charming grifter with a record as long as your arm.
Let's give him a big 'Jaws of Justice' welcome."

What do you get when you cross the legal system with office systems?

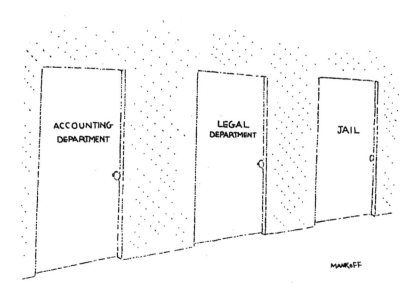

What do you get when you cross corporate perqs with corporal punishment?

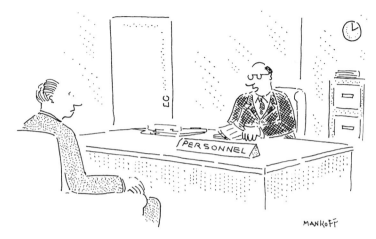

*"I think I should warn you that the flip side of our generous
bonus-incentive program is capital punishment."*

What do you get when you cross the judicial system with a game show?

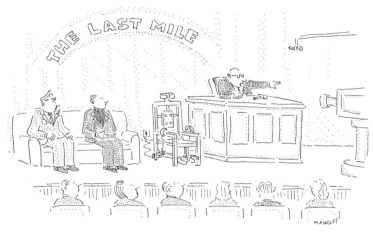

"And now let's welcome, for the first and last time . . ."

What do you get when you cross a holdup with a checkup?

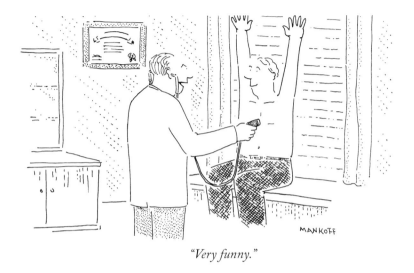

"Very funny."

What do you get when you cross hormone therapy with a hot car?

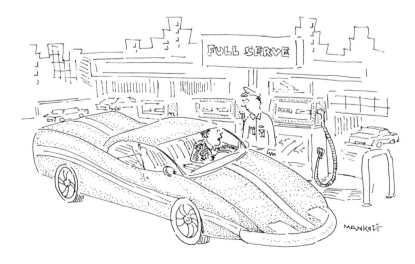

"Fill'er up with testosterone."

What do you get when you cross menswear with art?

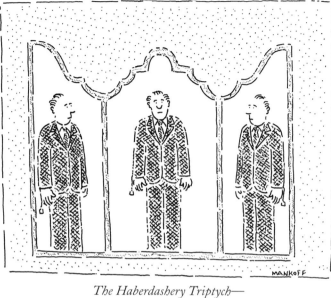

The Haberdashery Triptych—
the Barneys Collection, New York

What do you get when you cross haberdashery with TV news?

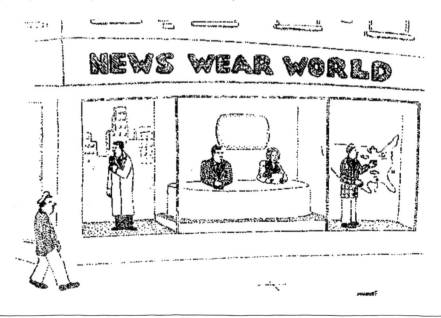

What do you get when you cross TV news and high art?

What do you get when you cross art with ... itself?

"I see your Granny Smith, and I raise you a
Golden Delicious."

Here are some more answers. It's your turn to supply the questions.

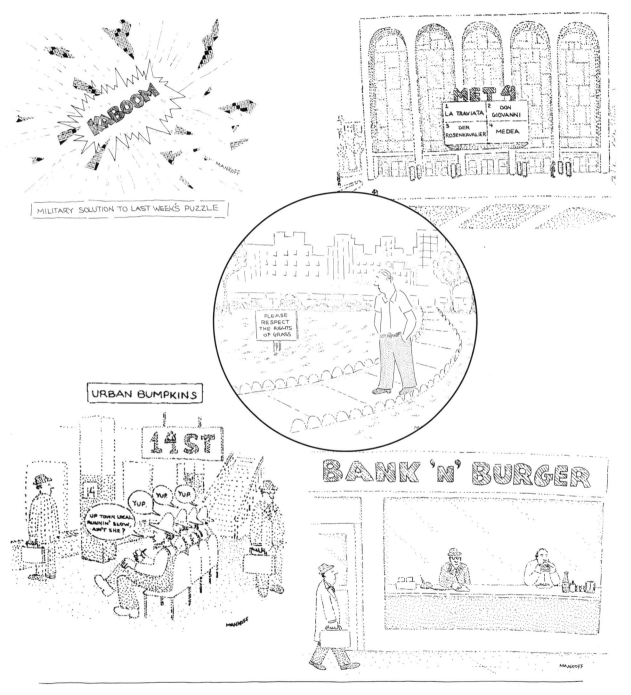

"So long, Bert."

"And on tap I've got Enfamil, Isomil,
and Gerber Lite."

"One last question, Berlinger. Is it just you, or is
the whole damn Accounting Department shot
full of steroids?"

So now you understand the cornerstone of the creative process. It's the combination of imagined things to make a new, previously unimagined thing.

The first step is imagining the real, which will always create something more and less than the real.

The second is realizing the imagined. This means making something that exists in the world outside of your imagination—a real object—a cartoon, for instance. Ink on paper, words and pictures.

5 The Real and the Imagined

How do I imagine the real?

Well, as a cartoonist I might start with a picture like this. What is it, really? It's a scene from a juvenile court in San Juan County, Washington.

Accompanying the picture is the information that San Juan County Juvenile Court Services endeavors to ensure that all contact with youths and their family members provides the opportunity for furthering the development and responsibility of the youths. Good for them. That's the reality. The unreality I'll create will be very different.

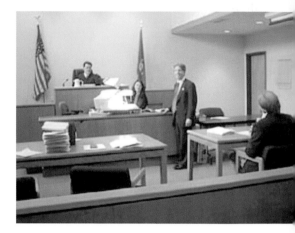

I might just take the phrase "Juvenile Court," play off the double meaning of the word "juvenile," map the world of childhood onto that of the legal system, and come up with this cartoon:

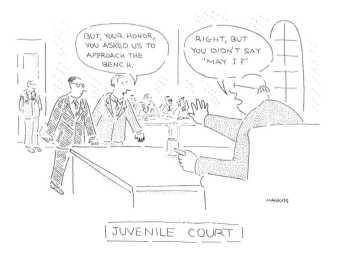

This combination has been made easier for me because of previous cartoons in which I imagined overlapping adult and child domains.

"All right, everybody, recess is over!"

"Tough noogies, chief—you forgot to call 'Reserved' when you left your desk."

Another way to go would be to start with the visual and end up ... well, let's see where we end up. Here are some snapshots of my unconscious as it deals with the original image:

I've dreamed up a drawing where everyone in the scene has a computer. Why? Who knows. The unconscious has reasons that reason cannot understand. And as the picture becomes blurred in my mind, it becomes like a Rorschach blot. My imagination sees what

isn't there. I imagine the real and, in so doing, make a new reality.

Then I just project myself into that new reality. Now, it's not the domains of childhood and the courts that are starting to blend but those of the courts and computer technology. It would be a mistake for me to focus too much on what the image I've created actually means. At this point, it's only in my mind. I've made it visible to you by drawing it. This is the stage I call "imagining the real." As soon as you imagine the real, rather than just looking at it, you are changing it.

Now I'm going to leave you for a while, while I go off and make some quick sketches from memory based on these images. Would you like some music while you're waiting? Here you go:

I'm back, and here's what I came up with.

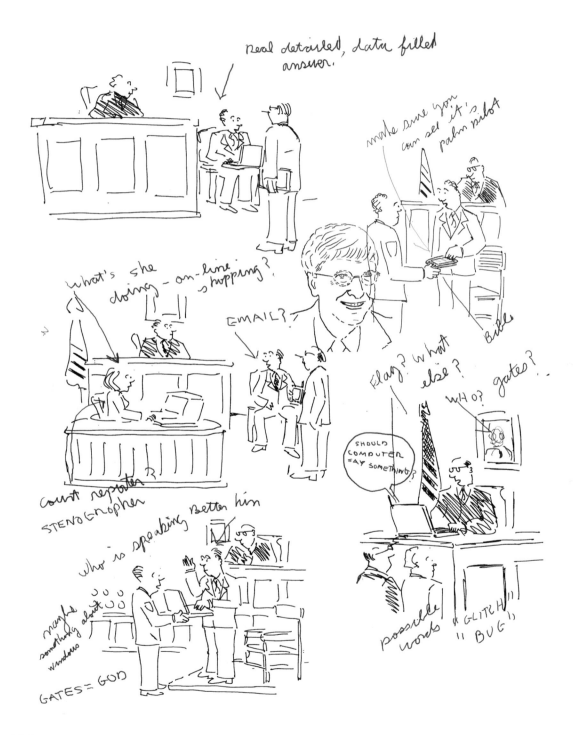

To really crank out ideas, the process must be spontaneous, almost like comedy improvisation. So I put myself in the picture like a Method actor. Once I'm there on the stand or in the judge's chair, things start popping out of my mouth.

I don't have to think about what I'm going to say in any of these roles. Language is spontaneous. We talk to people every day without first having to write out what we're going to say to them. Go ahead, put yourself into this drawing. Start feeling like a wise-ass. Smart-alecky, silly, whatever. Get into it. You'll think of something funny to say. What I thought of is on the next page.

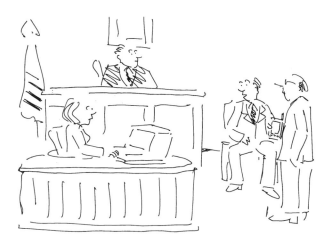

"If it's not too big a problem, I wonder if my testimony could be e-mailed to me after I'm done."

"We're going to have to recess— there's been a glitch in your sentencing."

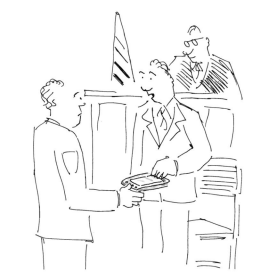

"You're sure the whole Bible is in here on a microchip no bigger than a man's thumb?"

"... so help me Gates."

I might now return to my original inspiration and continue this process of "creative looping." That is, imagining something; realizing the imagined; and then reimagining the newly realized. The loop (or loop de loop) moves forward, but, as in the previous chapter, it can also be played in reverse, and when it is, all past creations have the potential to be altered.

The image of Bill Gates was generated as an association during the sketching of imagined computer courtroom scenarios. Now it inserts itself into the original scenario like a portrait of Lincoln or Washington. It is also free to interact with the images and cartoons that led to its creation by association. As those images had a hand in creating it, it can be a force in re-creating them.

Gates Testifies Of Dire Results If Penalties Stand

By AMY HARMON

WASHINGTON, April 22 — Bill Gates, the chairman and co-founder of **Microsoft**, took the witness stand today for the first time in the antitrust case against the company, declaring that the penalties sought by a coalition of state prosecutors would cripple Microsoft, harm consumers and drag the entire computer industry into stagnation.

Opening his...

But now this hypothetical exercise begins to intersect and commingle with real-world events, because, as I'm writing this, well, you can read.

This event now becomes part of the loop and alters my creative vision.

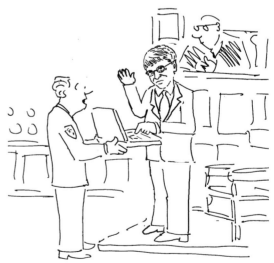

So I'm once again in the position of imagining the real, realizing the imagined, and so on and on.

"Don't you think it's time you upgraded to the Windows electronic version?"

"By clicking on the 'Accept' button you agree to be bound by the terms of this oath."

Of course, it's not unusual for real-world events to impinge upon and even instigate cartoons. If you're a cartoonist, keeping abreast of the news is part of the job description. Even now, I have to get an idea for *The New Yorker* on the issue of women choosing between having a career and having a baby. My deadline is tomorrow. But I also have to finish writing this book, so I'm going to try to do both, while you watch.

Now, to the task at hand. It turns out that career women who delay having a baby drastically reduce the odds that they will be able to have one at all. There are all kinds of statistics, charts, and books on this matter. Did you know that 27 is the age at which a woman's chances of getting pregnant begin to decline? Neither did I, and in coming up with an idea for a cartoon I will ignore this and all other facts. All I need to know is what's in this headline.

Babies vs. Career

WHICH SHOULD COME FIRST FOR WOMEN WHO WANT BOTH? The harsh facts about FERTILITY

That's all I want to know. That's the simplified, already modified, and distorted reality I have to project my imagination onto. It's been said that a little knowledge is a dangerous thing, but for generating cartoon ideas a little knowledge, or, at least incomplete knowledge, is a wonderful thing—an excellent springboard for ideas.

Complete knowledge is exclusionary and induces passivity. Incomplete knowledge invites and activates the imagination. Imaginative ideas have to travel light, stripped down to a sound-and-image bite that the creative mind can shuffle around as needed. In order to generate new ideas, this simplified, symbolic reality has to freely associate, connect with, and bounce off of other concepts and creations.

The fact that I've already applied the creative process to this area of career vs. motherhood of course makes it easier to start the loop.

The ideas I've already realized provide an idea embryo, pictured below, out of which new cartoons will develop. Why call it an embryo? Really, no reason, except that we're talking about babies, and as I was laying out these cartoons in overlapping circles they started to look vaguely like an embryo to me—so I called it an embryo. No good reason, except the unconscious has reasons of its own.

My Idea Embryo

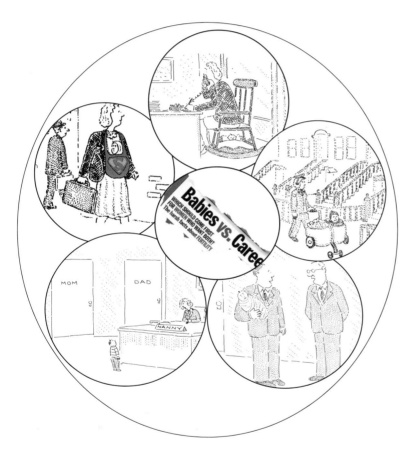

Real Embryo

Now the word and the image of an embryo start to slide me away from my former cartoons, which dealt with juggling the responsibilities of a child and a career. I begin to focus on this new topic, which is really fertility, and having to choose between pregnancy and a career.

Then when I look back at the photo of the embryo, having just written the words "pregnancy" and "fertility," I have a vision first of a pregnant embryo, and then of the 25,000-year-old Venus of Willendorf cave-art figurine that represents fertility.

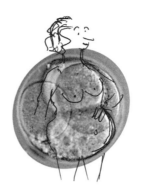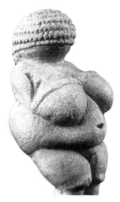

Clearly, Ms. Willendorf here had no trouble getting pregnant and having a career. In fact, you could say, her career was pregnancy. Funny concept. Yeah, what do you get when you cross pregnancy with a paycheck? Well, it's obvious—you get this:

"I never had to choose between a baby and a career—I'm a surrogate mother."

But it's not obvious. It wasn't even obvious to me. I didn't actually know where I was going until I got there, so how could you?

While there's method to the madness and vice versa, there's no plan of attack that can be anticipated or foreseen. Usually, when you try to accomplish something in the real world you clearly think out what you want to do beforehand. If your garage door is broken and you want it fixed, getting sidetracked on some other project won't help. But in the creative process getting sidetracked is key.

111

Often, the sidetrack turns out to be the main track for some great new idea. Sometimes it's not and the train derails, or hurtles headlong into another train, and all the ideas become horribly mangled so that it's hard for even their close cognitive relatives to identify them. Qualified conceptuologists must then be called in to try to make the identification through dental records (before it is realized that ideas don't have dental records).

Hmm. Clearly, I've become sidetracked here. Instead of completing this chapter in an orderly fashion, as my editor is begging me to do, the creativity of my unconscious intruded and fed me the above nonsense, which, in fact, is a pretty good example of the way my mind works. And, as a cartoonist, a licensed humorist, a certified creative, I am compelled by pride to ask the question "What if ideas had dental records?" But, fortunately, I don't have to answer it directly, because I'm better off answering it indirectly and getting sidetracked by the hypothetical worlds the question evokes. I'll probably end up creating a cartoon that may or may not have anything to do with ideas and their dental records, except as a starting point.

And every starting point is a fine starting point. Even dental records of ideas? Sure, I wouldn't even have come up with that phrase if unconsciously it didn't have potential.

But, whatever happens, I know that I can't possibly get any cartoon idea on this topic by consciously trying to. The more logical and the more planned the approach, the more certainly my conscious mind will elbow its way into the process, producing a completely uncreative result.

None of the techniques I've talked about can be practiced through conscious effort. Trying to get ideas is like trying to remember a name that's on the tip of your tongue. The harder you try, the more it eludes you. When it comes to ideas, conscious effort is conscious interference. The only way you can approach the task is obliquely.

6 Funny Is As Funny Does

Not everything creative is funny, but anything that's funny is creative. And while humor always rests on some sort of duality, contradiction, or paradox, some dualities are funny and others are just paradoxes.

This isn't all that funny ...

... while this is sort of funny ...

... and this is the funniest of all.

> THIS
> SENTENCE
> IS FALSE.

"No need to remind me. I'm well aware that I've forgotten completely about you."

There's only one really funny thing in the world. Us. People are funny. Cats can be pretty darn funny, you say. Nope. Cats don't crack each other up. Likewise, dogs. We laugh at them. They don't laugh at us. But of course we're not laughing at them; we're laughing at us. No animals were harmed in the making of these cartoons, because, hey, there are no animals in these cartoons. Just an imagined hybrid us that answers the question what do you get when you cross ...

... a cat and a CEO?

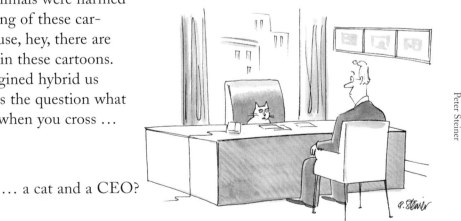

Peter Steiner

"You fed me tuna and cleaned my litter box, Harris, and I'm not going to forget it."

... a doctor and a rabbit?

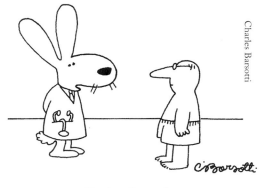

"Eat lots of carrots."

... a patient and a cow?

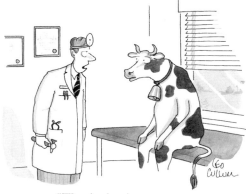

"The ringing in your ears—
I think I can help."

... a dog and a lawyer?

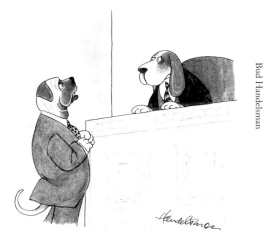

"I didn't realize, Your Honor. I assumed the law
here was the same as in New Jersey. As you may
know, dog eat dog is permissible there."

... a psychiartist and a fish?

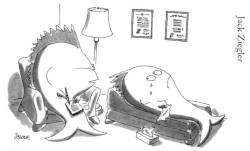

"Has it ever occurred to you to just say, 'Hey, I
quit. I don't want to be a part of the food chain
anymore'?"

These animal-people hybrids function as simplified emotional schemas, cute and cuddly models of our characteristics, desires, impulses, and failings. Animal cartoons are popular with cartoonists because they easily enable us to construct the classic foundation of a joke; the crossing of our ideals with our instincts. Our frontside and backside are exposed. Our duality is compressed into the singularity of a cartoon.

"Go for the one with the camcorder."

"It's not enough that we succeed. Cats must also fail."

WHAT LEMMINGS BELIEVE

"I'm sorry—here I am going on and on and I haven't asked you a thing about being caught in a trap."

This collision of what we wish we were with what we actually are is the bedrock on which funny (versus just amusing) cartoons depend. It is the most deeply resonant of all our comic tropes because it reveals who we are even, as in this all-time but very timely classic by Peter Steiner, when we're not there at all.

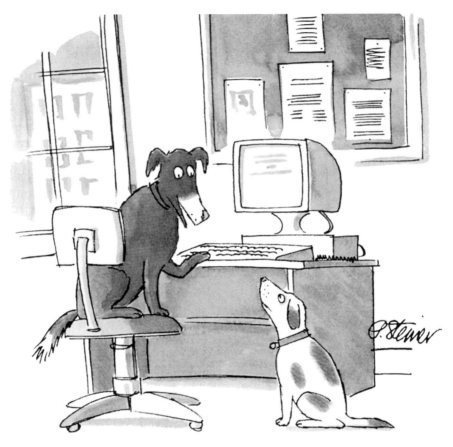

"On the Internet, nobody knows you're a dog."

Of course, this is not the only type of cartoon. But it is the only type that, when done right, has the possibility of being laugh-out-loud funny. Other cartoons, detached in varying degrees from the human condition, can be amusing, stimulating, thought-provoking, or even great. But not, I think, out-and-out funny.

Don't get me wrong, I like these other kinds of cartoons and do them whenever I can, because they represent genuine ideas and can evoke a smile—which is nothing to sneer at. (Or is it the other way around?) Anyway, here are some other kinds of cartoons to give you an idea of what I mean, and a smile if you're so inclined.

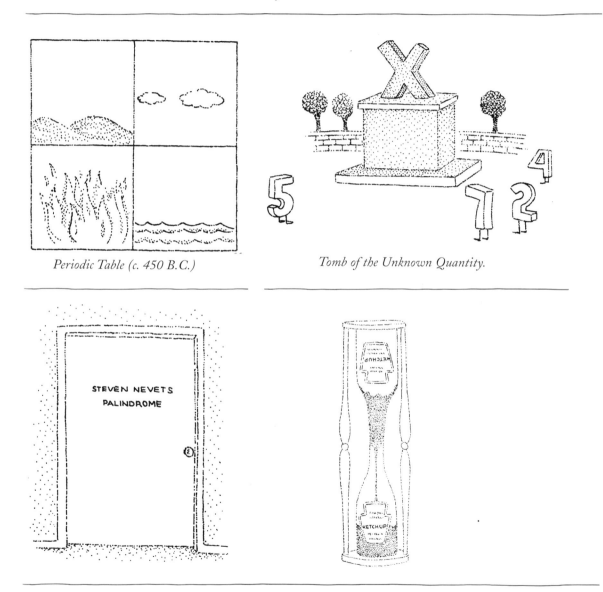

Periodic Table (c. 450 B.C.)

Tomb of the Unknown Quantity.

You might appreciate them, but you probably won't connect to them in a very personal way. They're much less likely to induce an out-loud laugh, like the ones on the next page.

"Mind if I put on the game?"

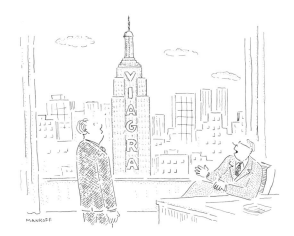

"Now, that's product placement!"

"If these walls could talk, and they knew
what was good for them, they'd shut the fuck up."

You laughed, right? Well, you did if my theory is correct. According to my theory, it is people who make us laugh. Us, them, anyone, everyone, the whole darn species. The things we do that point out the essential duality of being human. A mind in a body with a mind of its own. Incredible intelligence joined at the hip (and sometimes a little bit lower) with invincible stupidity. Even things that are just humorous, like puns, strike us as funny because they point to our essential duality. We are not simply one thing with one meaning, and neither are the words we've created.

To test my theory, I conducted an online survey at cartoonbank.com. I asked about one hundred people to go online and rate the eight cartoons you just saw for funniness. The rating scale was from 1 to 10, with 10 representing the funniest.

Each subject (I'll get that Ph.D. yet!) saw the cartoons in a randomized order to eliminate sequence effects. Here's what the survey looked like. (Once again, no animals were harmed during this research, although an adorable little bunny was sacrificed afterward for good luck.)

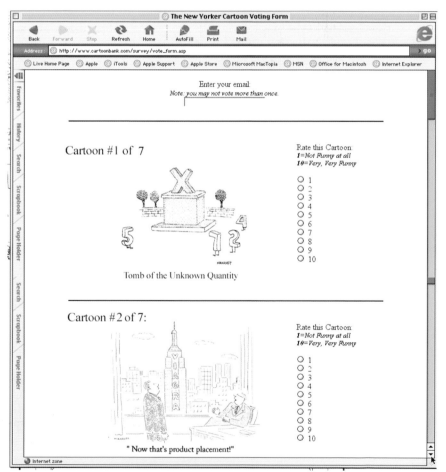

Here are the results:

The Viagra gag placed first, getting a rating of just over 7. (Incidentally, when I give slide shows I've found a rating of 7 and above to be a very good predictor of an actual laugh in an audience.) Fairly closely bunched after that one were three others, all of which involve people acting out their motives, desires, conflicts, and absurdities.

After the people jokes, there's a big gap to the more cerebral and abstract jokes, which people rate as considerably less funny. Many people tell me they like these cartoons and find them clever rather than funny. They're not failed gags. They're not cartoons that tried to get a laugh but flopped. They are just cartoons that succeed in conveying some abstract concept in a humorous way. All of them are still, in the end, about people, just not the things about people that make us laugh.

Rank	Name	Average	Std Dev	Total	# of Votes	Comments
1	Viagra	7.09	2.11	532	75	Comments
2	Mind if I put on the game	6.88	2.08	550	80	Comments
3	Shut the fuck up	6.68	2.44	501	75	Comments
4	Tomb of Unkown Quantity	5.23	2.26	418	80	Comments
5	Ketchup Hourglass	5.03	2.42	392	78	Comments
6	Periodic Table	4.79	2.34	369	77	Comments
7	Palindrome	4.39	2.37	329	75	Comments

But, speaking of laughs, there is one of my cartoons that everyone finds funny. At least, everyone tells me it is a favorite.

Here it is:

"No, Thursday's out. How about never— is never good for you?"

But does *everyone* find it funny? Is it even rated as highly as some of the other cartoons we've been looking at?

I did another online survey to find out. This time I sent it, along with others to be rated, separately to a thousand men and a thousand women. About a third of each group responded.

There were some interesting results. On average, women rated the cartoon higher than men (8.37 vs. 7.89), and women were more likely than men (40 percent to 28 percent) to assign the highest rating, a 10. About 80 percent of all entrants rated this cartoon a 7 or above. So, by any measure, this is a very funny cartoon. Certainly the most highly rated cartoon for funniness that I ever did, or (sob) probably ever will do.

WOMEN

**AVERAGE VOTE
RESULT: 8.37**
Total Vote Points: 2755
Standard Deviation: 2.05
Number of votes
cast: 329

The Vote Result for this cartoon

Vote Points	Counts
1	4
2	2
3	7
4	5
5	19
6	16
7	36
8	41
9	55
10	144

MEN

**AVERAGE VOTE
RESULT: 7.89**
Total Vote Points: 2509
Standard Deviation: 2.12
Number of votes
cast: 318

The Vote Result for this cartoon

Vote Points	Counts
1	5
2	3
3	10
4	7
5	16
6	25
7	46
8	57
9	58
10	91

This, of course, doesn't mean that everyone finds it funny. Some people thought this very funny cartoon was so unfunny that they gave it the lowest possible rating, a 1. That just goes to show that you can't please everyone—especially morons. Ooh, that was mean, wasn't it? And it was funny (just like the cartoon) for exactly the same reason.

What does all this prove? Only that the analysis of humor is not an exact science, or even a science at all. All I'm trying to do is push it into the realm of a respectable pseudoscience.

Rather than sum up this section with any more data, I think it would be appropriate to do it with a cartoon that both illustrates and encapsulates my philosophy:

"You are fair, compassionate, and intelligent,
but you are perceived as biased, callous, and dumb."

But philosophy will take you only so far in the quest for funny. You still need some rules. Here's your A-to-Z guide to funniness by way of a cartoon test. In each instance, a cartoon appears with several slight variations. One and only one is the funniest. (Okay, maybe two, but only two.) The choice is yours. And by the time you get to the letter Z, you'll be ready to apply for your humor license.

The Cartoon I.Q. Test

1

a.

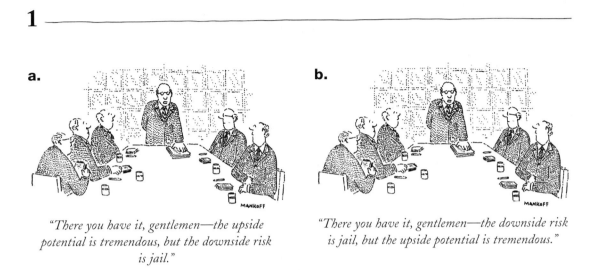

"There you have it, gentlemen—the upside potential is tremendous, but the downside risk is jail."

b.

"There you have it, gentlemen—the downside risk is jail, but the upside potential is tremendous."

2

That wasn't too hard, was it? Now, if you got that one right, you should have no trouble figuring out where the same one-word punch line should go in this door gag.

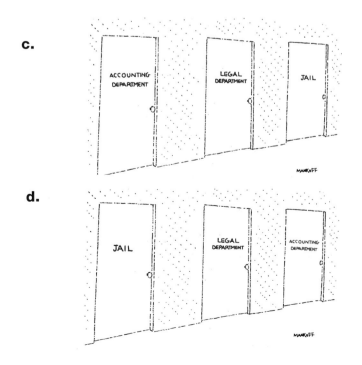

c.

d.

The rule here is that the punch line—to have punch—should be surprising. No surprise, no laugh. Therefore it should come at the end. In visual jokes, especially where reading within the cartoon frame is involved, the joke should always run from left to right (unless you're in Israel).

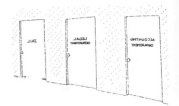

3

Okay, how about this one?
It's a little trickier.

e.

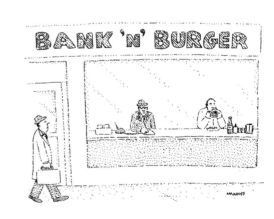

f.

Intuitively, you know it's (f), but it might seem that either the word "bank" or the word "burger" could provide the surprise. To some extent that's true, but besides moving from left to right, a joke should always progress from the more elevated behavior to the more instinctive. Saving money may not be the highest human activity, but it ranks above stuffing your face.

Also, if you were just to rank words on a scale of funniness, you would rank "burger" higher than "bank" for many linguistic and semantic considerations, including the fact that it has a strong auditory resemblance to the word "booger." So put the funny last.

4 ———————————————————————————————

Moving right along. Would (g) now be funnier than (f)?
No. It does have some things going for it—actually, one
thing, but even that one, usually very reliable thing
comes after the joke has already been made.

g.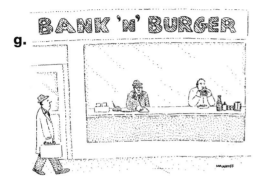

h.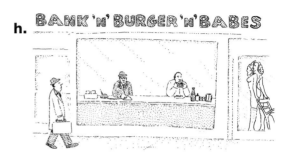

5 ———————————————————————————————

Here's another one.

i.

*"You're doing a good job, Davis, but it's come to my
attention that you're a fugitive from a chain gang."*

j.

*"You're doing a good job, Throttlebottom,
but it's come to my attention that you're a
fugitive from a chain gang."*

k.

*"You're doing a good job, Davis, but it's come to my
attention that you're a fugitive from a chain gang."*

Both (j) and (k) try to make the joke
funnier by adding either a silly name
or a facial expression. Since neither
is integral, they distract and subtract
instead.

Ooh! This is a toughie. If I weren't the one making up the answers, this one might stump even me. You go ahead. Take a shot at it—if you get it right, you'll earn extra credit.

l.

"I don't know how you do it. If I had your job, I'd go nuts."

m.

"I don't know how you do it. If I had your job, I'd go nuts."

n.

"I don't know how you do it. If I had your job, I'd go nuts."

In order of funniness, the cartoons rank (m), (l), (n). When we're contrasting what we seem to be with what we actually are, the greater the gap, the funnier the scenario. If the boss, who, we infer, is very important, is actually "tongue-out-the-mouth" bonkers, that's funnier than if the underling is. And (m) is inherently more

plausible than (l). We can easily imagine the crazy boss turning around and switching back to a normal face. Cartoon (n) fails because the insane employee is now saying he would go nuts if he had the boss's job, when clearly he's nuts to start with.

Authority figures like bosses or generals are often used in cartoons exactly because it is easy to subvert our expectations of them. The greater the difference between what the authority projects and what the cartoon delivers, the funnier it will be.

o.

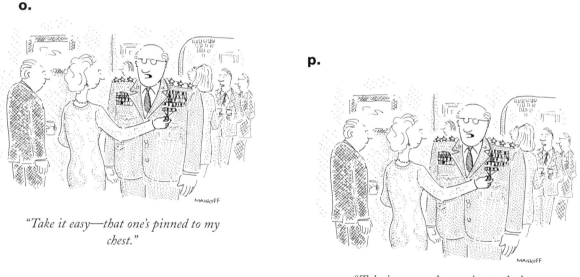

"Take it easy—that one's pinned to my chest."

p.

"Take it easy—that one's attached to my nipple."

In (o), the medal is pinned to his chest. Okay, that's how tough he is. He's expected to be tough—he's a general. But (p), which depicts a general sporting a medal as a nipple ring, creates not merely a gap between the expected and the unexpected but a chasm.

Relax, you're more than halfway through now. You should be 100 percent funnier than you were when you started, ten pounds lighter while eating all the foods you crave, and you've probably added inches to your penis and/or breasts.

Questions 7, 8, 9, 10, and 11 revolve around the same basic principles (which I'll think of by the time you finish the quiz).

7

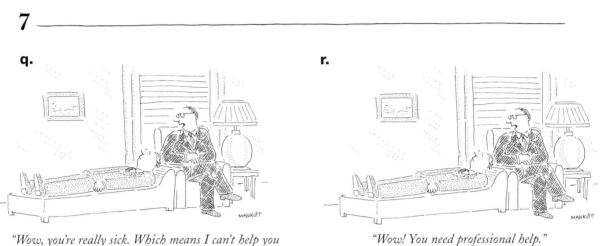

q.

"Wow, you're really sick. Which means I can't help you because I'm not actually a psychiatrist.

r.

"Wow! You need professional help."

8

s.

"Hi. I'm, I'm, I'm ... You'll have to forgive me, I'm terrible with names."

t.

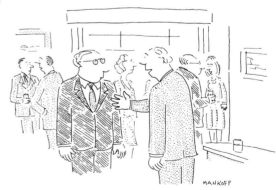

Hi. I'd like to introduce myself, but I'm so bad with names I can't even remember my own.

u.

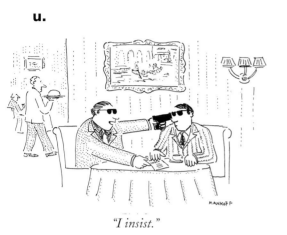

"I insist."

v.

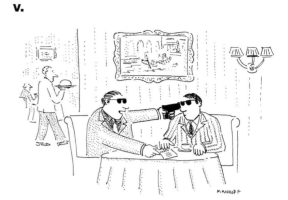

*"Please, let me get the check or I'll blow
your fucking head off."*

w.

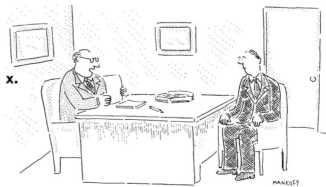

*"I gotta tell ya, these embezzlement
convictions raise a red flag."*

x.

*"I gotta tell ya, these embezzlement convictions
make you unfit for employment."*

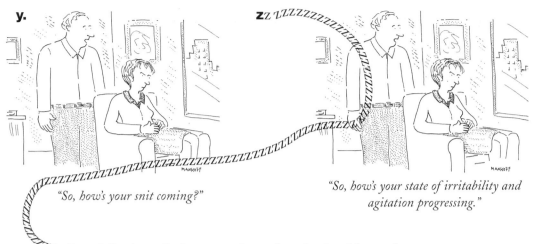

"So, how's your snit coming?"

"So, how's your state of irritability and agitation progressing."

Oops! Seeing all those versions that don't address the fact that what you leave out of a joke is just as important as what you include put me to sleep. Fact is, the whole chapter made me a little drowsy. It's sort of tedious dissecting humor. It's been likened to dissecting a frog. Nobody is much interested, and the frog dies. But you've been a good sport, so I think it's time to join that party I invited you to on the very first page of this book. By now you should have exactly the right mind-set to feel at home with this group. And don't worry, be funny. But, hey, take that banana out of your ear—it's been done.

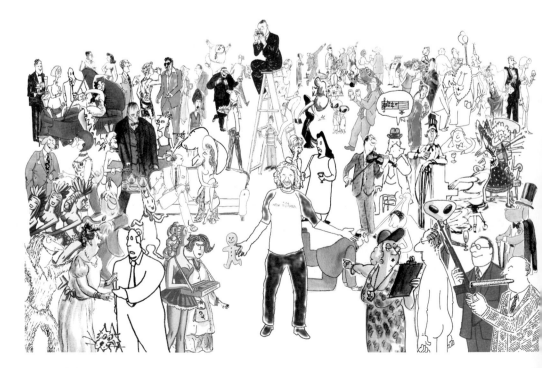

7 Where Do You Get Your Ideas?

When I got the advance payment to write this book on cartooning and creativity, my first question to the publisher was "Uh, how many pages?" When they answered 672, I said, "Way, way too many. I'm not a writer. Why don't we compromise? How about six, which *was* a number included in your original figure?" Eventually, we agreed to a total of 144.

But as you can see, I'm basically done—and I'm only on page 131. I could make

the type really, really big and hope you wouldn't notice, or

I could make the margins incredibly large, like this, but, though cute, that just won't cut it.

Instead, I've decided to rope in some of my friends and colleagues to help me: Mick Stevens, Jack Ziegler, Roz Chast, David Sipress, Victoria Roberts, Barbara Smaller, Marisa Acocella, P. C. Vey, Gahan Wilson, Peter Steiner, and Mort Gerberg. They all agreed to answer the question cartoonists always get, "Where do you get your ideas?," in their own inimitable fashion. What they turned in was so great that I didn't want to use it, because, frankly, it kind of makes all the previous pages I've done look like padding.

So be it.

Roz Chast

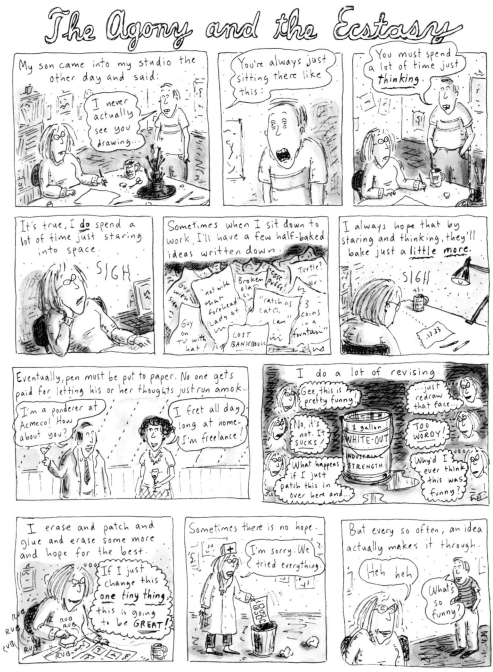

Barbara Smaller

Jack Ziegler

A. Fax machine
B. Stereo equipment
C. Books
D. Toy cars
E. Supply closet
F. Artwork
G. 30-drawer file of rejected drawings
H. Copier
I. Desk file filled with ongoing and long-abandoned projects
J. Drawing utensils & cocktail stirrers

K. Light box
L. Dog
M. View of Lone Mountain
N. Magazines
O. More books (rear view)
P. Latest reading material
Q. Beverage
R. Clipboard
S. LPs
T. Today's *New York Times*
U. Telephone
V. CDs
W. Drafting table

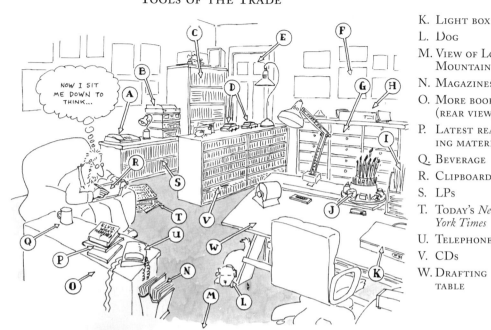

Okay, that's me there, sitting in an overstuffed chair in the north-east corner of my studio, trying to come up with some funny ideas. As you can see, this room, a converted bedroom, is chock-full of many diversions, not the least of which is the view out my window of Lone Mountain, a chunk of land thrust up some time ago by the movement of the glaciers during the last Ice Age. If I detect the slightest flurry of activity on the mountain, I can get a closer look with a pair of binoculars in the bookcase to my right. Carefully arranged throughout the rest of my studio are various shelvings of books, CDs, records, toys, art, etc. It's the ninth such studio I've had in the past thirty years, and a comfortable place from which to start my morning, which typically begins by check-ing my clipboard to see if anything is jotted down from the previ-ous day. Usually there's nothing, but on occasion I'll have a word or phrase I've overheard, a fragment from a dream, a random thought, or anything that might have potential. If confronted with a blank sheet of paper, I go to that day's *New York Times* and scan

134

the front page of each section, taking notes. If I have at least one thing written down on the clipboard, I can almost always get an idea out of it. I just keep fooling around, drawing odd bits here and there, until something starts to jell. Sometimes these doodles lead in a direction that has nothing at all to do with the word I wrote down in the first place, and something entirely new emerges. Maybe I'm drawing and I sort of like what I'm doing.

I like the picture that's evolving. Sometimes I box myself into a corner and have to fight my way out, and all the while I'm thinking, Gee, I'd really like to fit this image into something I can use.

And that's where I usually run into trouble. I might spend two hours trying to dig myself out of the hole that I've dug, because I know in my heart that I am definitely going to get something out of this image. Usually some sort of idea eventually comes, although quite often it's not very good. But I draw it up anyway and submit it because, hey, I've just wasted two hours on this goddam thing and I want somebody else to share the pain.

If the *New York Times* fails me and there's still not a single note on my clipboard, I'm forced to revert to the hard discipline of daydreaming, a meandering that often leads nowhere but occasionally unearths a gem or two. I keep drawing and free-associating, letting one thing lead to another.

Sometimes I find a groove and things start happening. I stumble into one idea and that one leads to another. It's a sort of adrenaline rush that, after a while, peters out and, when I realize that there's nothing left, I gather these rough scribblings and stash them away. I don't look at them again until the day I actually draw them up for submission. I then do some altering and fine-tuning on the ones I can use. The rest I toss out. I render what's left into near-finished art and send those drawings off into the world, where about 10 percent of them get jobs in the pages of *The New Yorker*.

The others, losers and crybabies that they are, eventually return home to live off their dad.

David Sipress

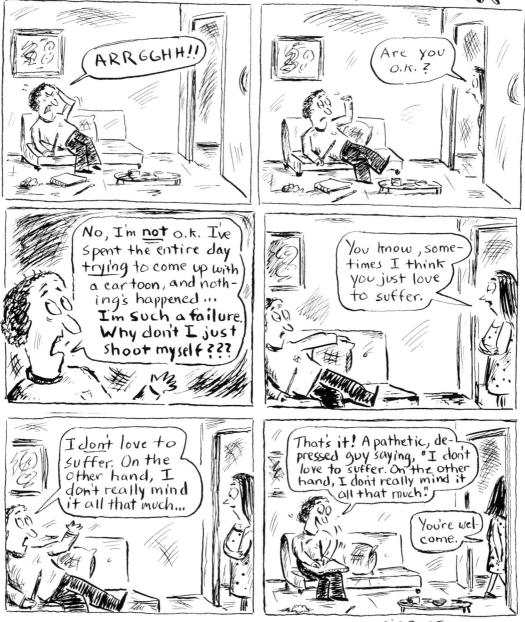

Victoria Roberts

MY DEADLINE DAY by Victoria Roberts

10 A.M. I AWAKEN. THE DOG IS STILL SLEEPING. I WATCH TWO RERUNS OF "THE NANNY." UH-OH! IT'S DEADLINE DAY!

11 A.M. I WAKE THE DOG UP. I SHOULD START WORK SOON. I READ THE PAPER FIRST.

MIDDAY. CAN'T THINK OF ANYTHING BRILLIANT JUST NOW. I TAKE A BUBBLE BATH.

1 P.M. CAN'T WORK ON AN EMPTY STOMACH—LEAN CUISINE MACARONI AND CHEESE. I WATCH HALF A "JENNY" RERUN FOLLOWED BY A "CHARLIE ROSE" RERUN.

2:30 P.M. TOO TIRED TO WORK. I FALL ASLEEP ON THE SOFA, BUT I DON'T DREAM. IF I HAVE A LITTLE REST I'LL BE ABLE TO WORK LATER.

3:30 P.M. I AWAKEN BUT MY BRAIN STILL ISN'T WORKING. I GO FOR A SWIM. EXERCIZE WILL HELP ME WORK.

5 P.M. I'M TOO WOUND UP FROM SWIMMING TO WORK. I WATCH "RIKKI LAKE", THE NEWS, "ENTERTAINMENT TONIGHT"...

11 P.M. LOOK AT THE TIME! DON'T WANT TO MISS "FRIENDS" RERUN. I TURN THE T.V. AROUND AND GO TO MY DESK.

11:17 P.M. I TURN THE T.V. SET ON "MUTE." I TURN OUT TWENTY CARTOONS—ONE OF THEM WORKS. I AM A LUCKY WOMAN.

137

Marisa Acocella

WHAT THEY DON'T KNOW...

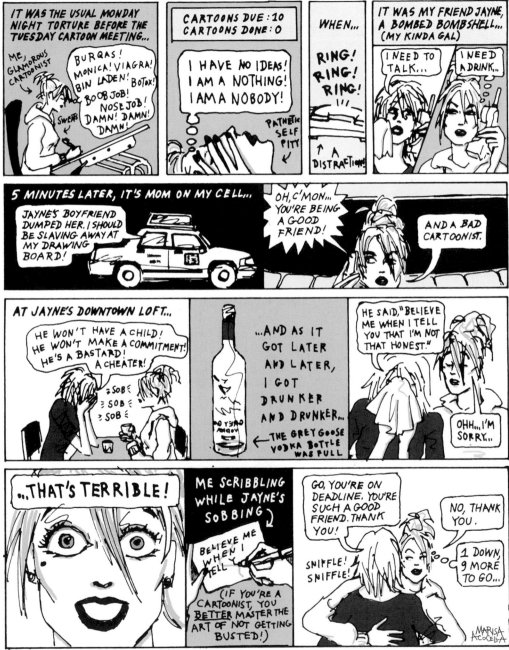

Mort Gerberg

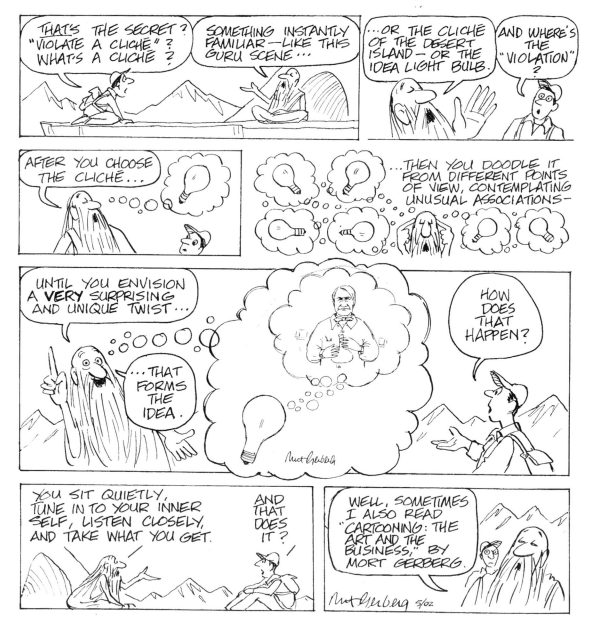

THE SECRET OF GETTING CARTOON IDEAS

THAT'S THE SECRET? "VIOLATE A CLICHÉ"? WHAT'S A CLICHÉ?

SOMETHING INSTANTLY FAMILIAR—LIKE THIS GURU SCENE···

···OR THE CLICHÉ OF THE DESERT ISLAND—OR THE IDEA LIGHT BULB.

AND WHERE'S THE "VIOLATION"?

AFTER YOU CHOOSE THE CLICHÉ···

···THEN YOU DOODLE IT FROM DIFFERENT POINTS OF VIEW, CONTEMPLATING UNUSUAL ASSOCIATIONS—

UNTIL YOU ENVISION A **VERY** SURPRISING AND UNIQUE TWIST···

···THAT FORMS THE IDEA.

HOW DOES THAT HAPPEN?

YOU SIT QUIETLY, TUNE IN TO YOUR INNER SELF, LISTEN CLOSELY, AND TAKE WHAT YOU GET.

AND THAT DOES IT?

WELL, SOMETIMES I ALSO READ "CARTOONING: THE ART AND THE BUSINESS," BY MORT GERBERG.

Gahan Wilson

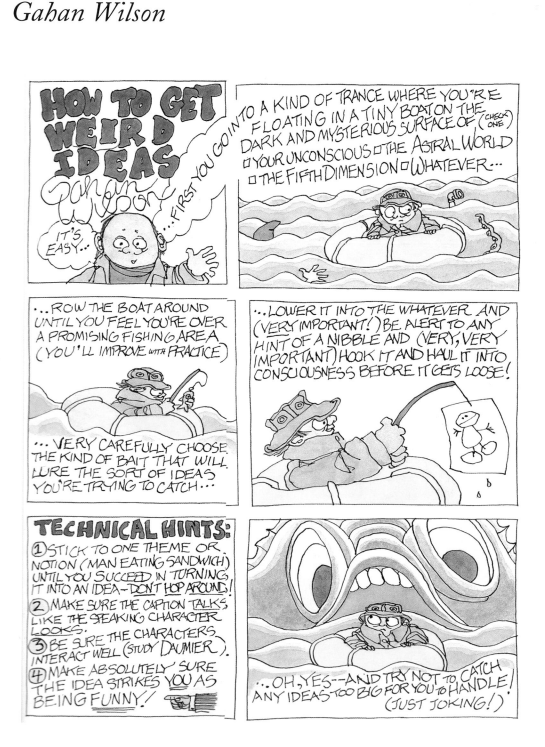

Mick Stevens

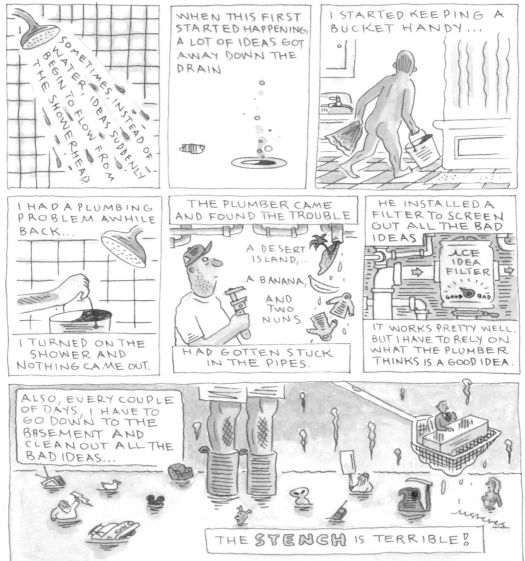

Peter Steiner

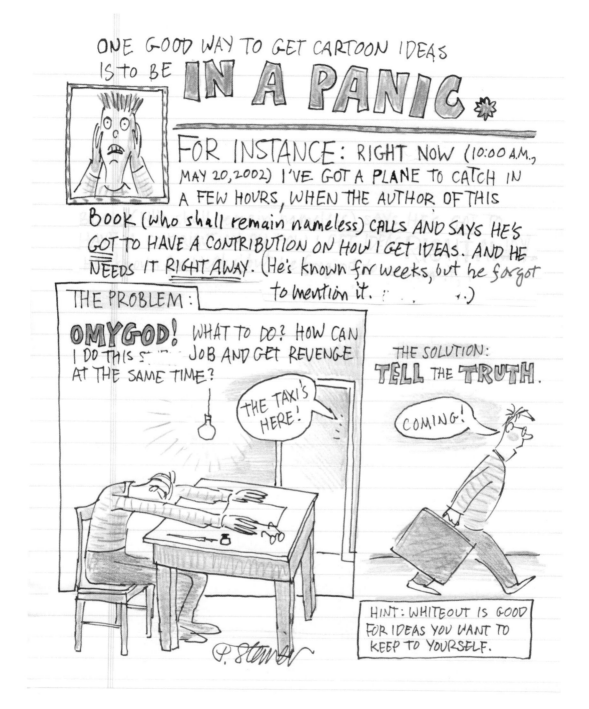

143

Index of Cartoonists